ABERDOUR &
DALGETY BAY

THROUGH TIME

Eric Simpson

AMBERLEY PUBLISHING

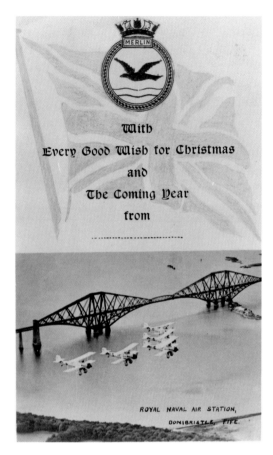

A Second World War Christmas postcard from
the Fleet Air Arm station at Donibristle.

First published 2010

Amberley Publishing
Cirencester Road, Chalford,
Stroud, Gloucestershire, GL6 8PE

www.amberley-books.com

Copyright © Eric Simpson, 2010

The right of Eric Simpson to be identified as the
Author of this work has been asserted in accordance
with the Copyrights, Designs and Patents Act 1988.

ISBN 978 1 84868 769 1

British Library Cataloguing in Publication Data.
A catalogue record for this book is available from
the British Library.

Typeset in 9.5pt on 12pt Celeste.
Typesetting by Amberley Publishing.
Printed in the UK.

Introduction

Dalgety Bay has grown into a considerable community. But when, in May 1966, I, with my family, came to stay, it was just a tiny settlement with only about twelve houses occupied. That same year I was invited to give a series of local history lectures in Aberdour. This started an interest in the history of the two closely-linked communities which I have maintained over the years. My research into the history of the two areas included taking photographs of the passing scene. Some of these images have been included in this work, the history of the recent past having at least as much relevance as more distant events.

Whilst the two communities have very different histories, they are linked in one significant way, inasmuch as much of Wester Aberdour and most of Dalgety Bay formed part of the former Donibristle Estate of the Earls of Moray. This estate was transformed when, during the First World War, a military airfield was built on part of the ground. Greatly expanded during the Second World War, the Fleet Air Arm station, HMS *Merlin*, and Donibristle Aircraft Repair Yard made a major contribution to the war effort. Post-war closure was at first catastrophic for the area (many Aberdour people worked at the base), but new life and vigour came with the opening of industrial estates on the yard's site and the decision to build a private-enterprise new town on the rest of the earl's Donibristle estate.

Aberdour's transformation had come earlier, when, in the nineteenth century, it had developed from a weaving village and minor coal-exporting port into a holiday-seekers' haven. As with other seaside resorts, the tourist trade is not what it was. Nevertheless, the village remains popular with day visitors, and when the sun shines its beaches still draw the crowds. As for the erstwhile coal port, its popularity with yachties probably renders it more popular than it ever was. Not that Dalgety Bay is backward in that respect. Its yacht club is one of the largest in the east of Scotland. Ironically, when Dalgety Bay was further expanded to embrace St Davids, another historic coal port, what was left of that harbour was left empty, a semi-ornamental shell.

In the order of the images I have selected for Dalgety Bay I have taken a chronological approach, a very approximate one I stress. For Aberdour it is a geographic approach, again a very rough one. Starting from the centre, the images radiate out like the spokes of a wheel along the main arteries. The formal eastern gateway to the former Donibristle Estate provides the last image leading to the old estate avenue which links the two communities.

In a short introduction, it is not possible to give a detailed history of the two communities. As I have written four books and various articles on the area, I point to these and other works for further information on the subject.

Eric Simpson
September 2010

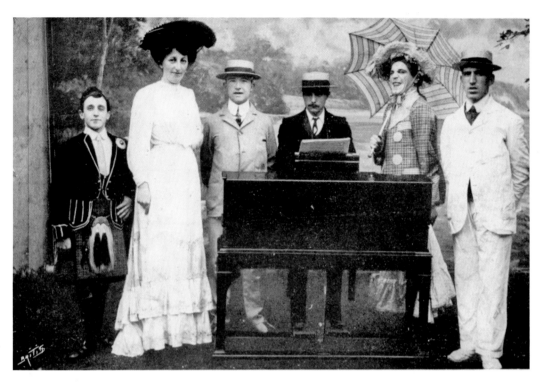

Pierrot Troupes
Two old Aberdour postcards showing two very different pierrot troupes.

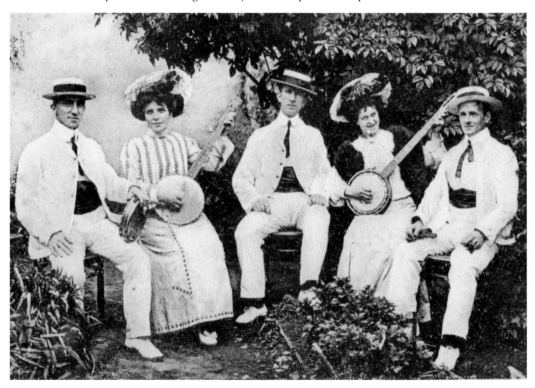

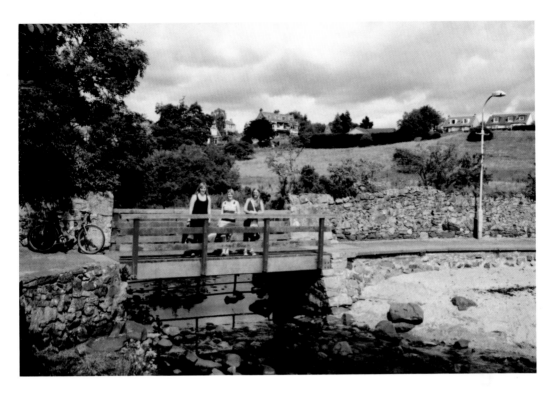

The Dour Burn

It is fitting to start with the Dour Burn at the point where it bequeaths its name to the village, since Aber is a Pictish word for 'mouth of'. To provide contrast in fashion styles, good fortune brought three comely lasses along at the right time. Home Park, behind, was originally Cow Park. The area where the houses stand was bought by Edinburgh developers in 1871, but this speculative development proved to be a dead loss.

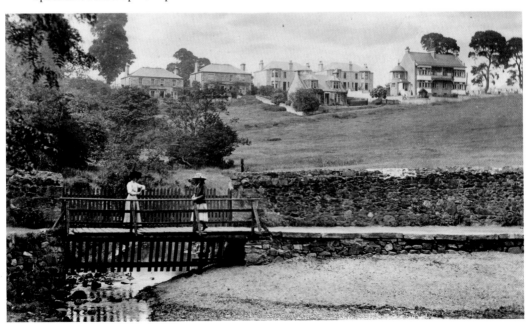

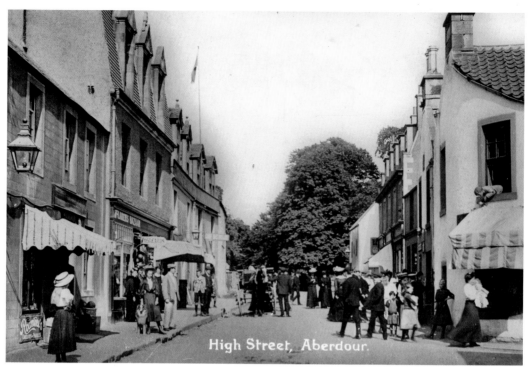

High Street View I

Harriet Comfort, the young lady on the extreme left of this old postcard, looks out on Aberdour High Street where pedestrians stroll in casual fashion – not to be risked today. An art gallery has replaced the butcher's shop on the right.

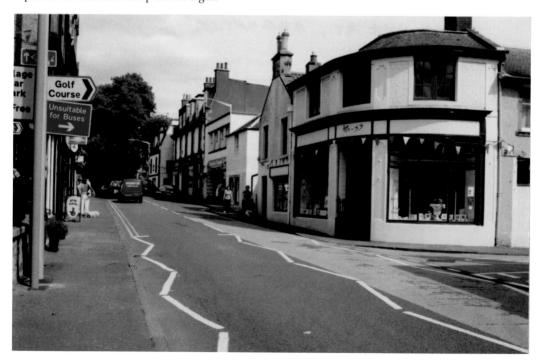

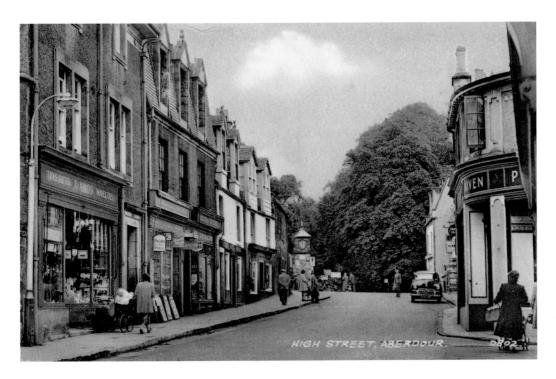

High Street View II
Fifty years later the Dr Spence Memorial Clock is visible at the far end of the High Street. Originally it fronted the former kirk which now serves as the church hall. It was flitted from its original location to make way for the war memorial. Niven's butcher shop has had its upper storey refashioned and electric street lighting has replaced gas.

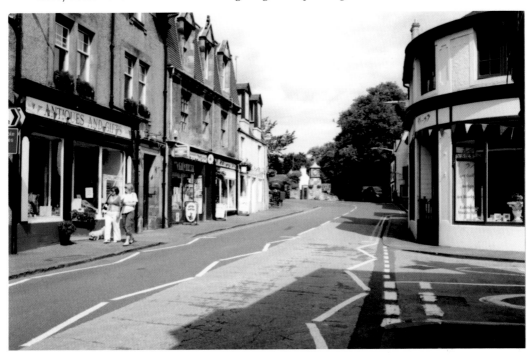

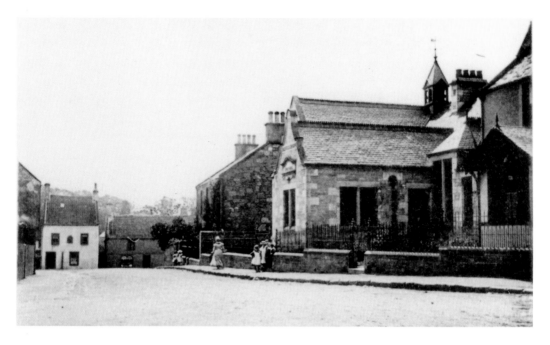

From School to Garden

The old primary school is the main feature in the old image. As the colour photograph shows, the space has been filled with ornamental shrubbery, though at the time of writing this area is being refashioned as a Sensory Garden. This school continued in use till 1967. The author's daughter was one of the last to enrol in the infant class in that year – into a classroom with an open fire.

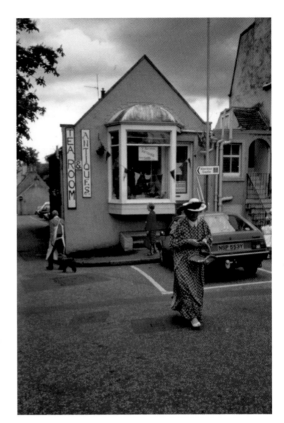

Victoria Day 1990

In 1990 the end house on High Street was an antique shop-cum-tearoom. Aberdour was celebrating a special Victoria Day, so the lady in the foreground was, like many other residents, dressed for the occasion.

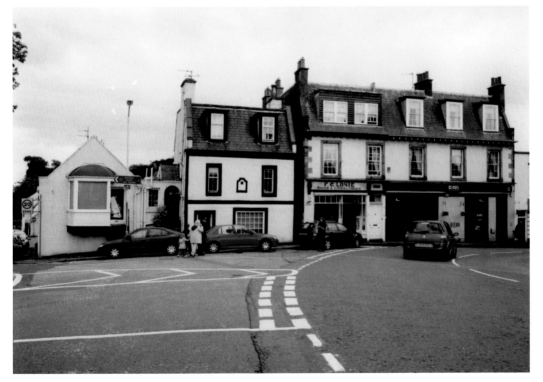

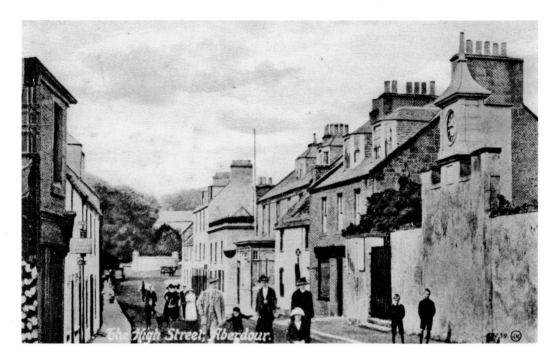

The Dr Spence Memorial Clock

In the Edwardian image the then parish kirk was fronted by a formidable dyke that was topped by the Dr Spence Memorial Clock of 1910. This image has been altered, most of the figures in the street not appearing in the original Edwardian photograph. Giving postcards a more up-to-date look was common practice with the Valentine firm of publishers. The two Crow boys on the right did appear in the original photograph.

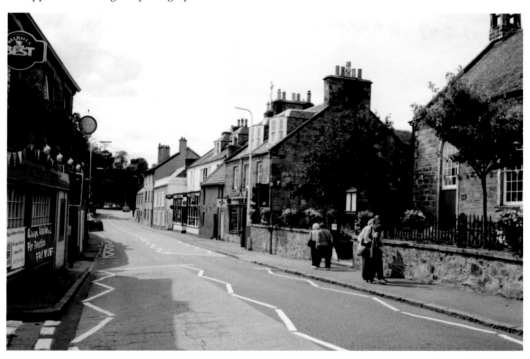

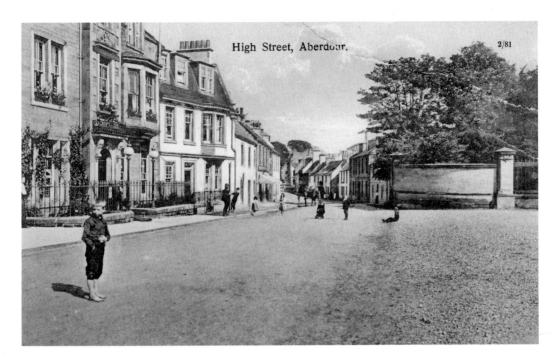

From Bell Inn to Woodside

The Woodside Hotel on the left had been upgraded from the humble Bell Inn where, in the early 1850s, travellers could be 'temporarily accommodated'. Ann Greig, whose husband Robert had been the publican in 1841, was then the innkeeper. Succeeded successively by sons Andrew and Alexander, it was unsurprisingly known as Greig's Hotel. Rebuilt in 1873, it was later renamed the Woodside.

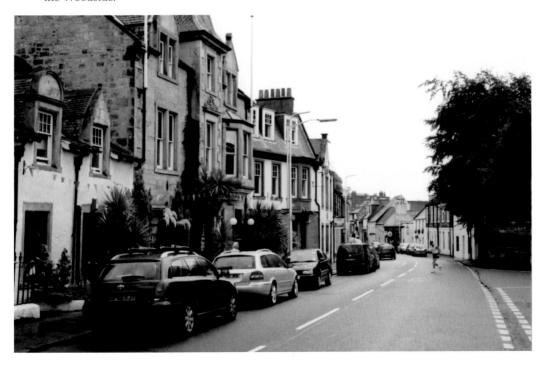

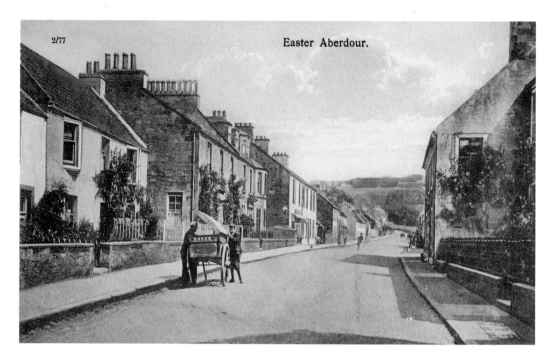

Easter Aberdour.

Easter Aberdour

No yellow lines needed in Aberdour's Main Street for this baker's delivery barrow. In the 1850s Easter Aberdour, or the Old Town as it was alternatively called, consisted of 'very old houses, chiefly cottages'. There were twenty-nine paupers living in the village as a whole in 1851 and twenty-four of them lived in Easter Aberdour.

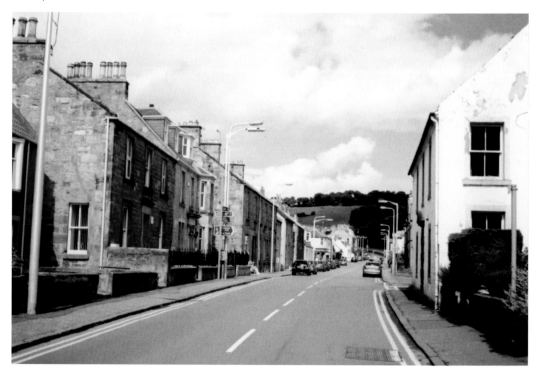

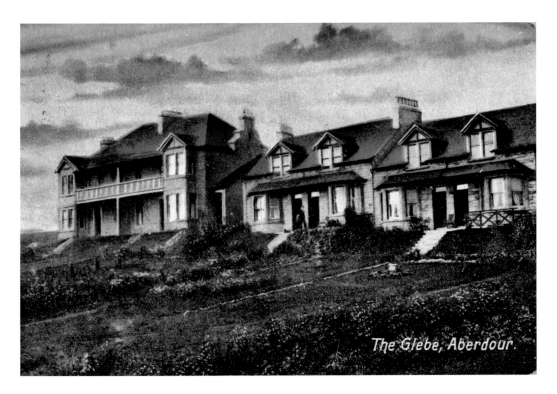

The Glebe, Aberdour.

Kirk and Glebe

As it is difficult to replicate the interior of the church hall, I have brought these two old postcards together. They were once tied, inasmuch as the lands of the glebe contributed to the minister's income. What was then the parish kirk, erected in 1790, is now the church hall and the glebe lands were used for housing.

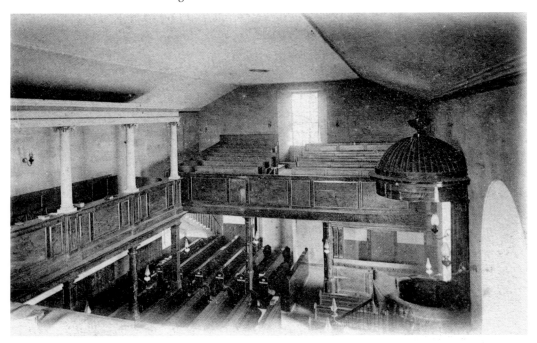

The Auld Town

In the early 1900s there was no need for a pedestrian crossing. The houses with forestairs were removed prior to 1933. When some of the buildings in the middle distance were removed, a new access route to the historic Murrell Road was built. The old road to The Murrell went via Murrell Terrace, and thereafter joined the old road.

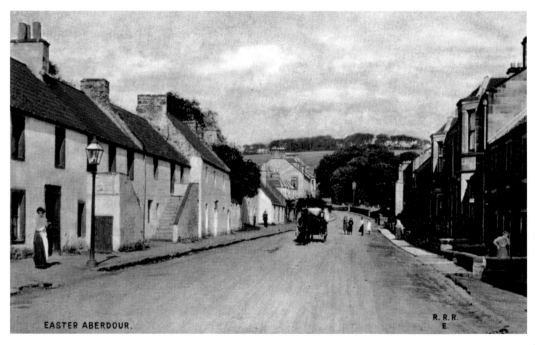

EASTER ABERDOUR.

R. R. R.
E.

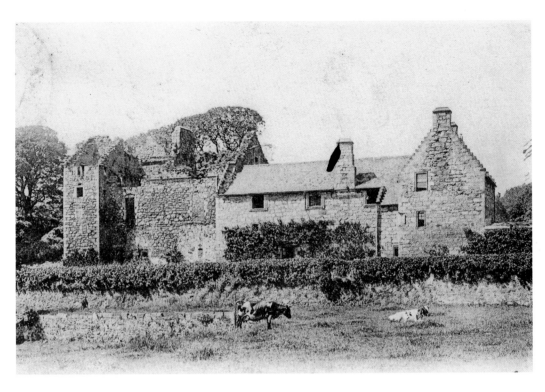

Aberdour Castle I
There are no cows grazing now that close to Aberdour Castle. The terrace walls to the south of the castle were rebuilt from the 1980s. The castle was a popular place for a school visit in June 2009.

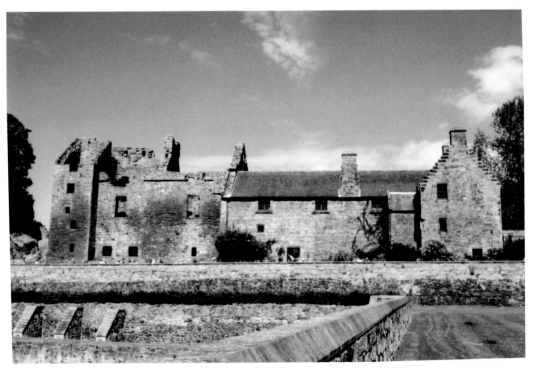

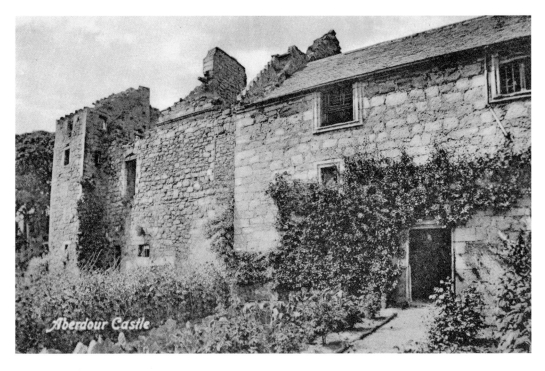

Aberdour Castle II

The picnic tables with empty wine glasses and the manicured lawn are quite a change from its more picturesque Edwardian setting. And they are well used by the wedding parties and school groups, who are frequent visitors to the castle.

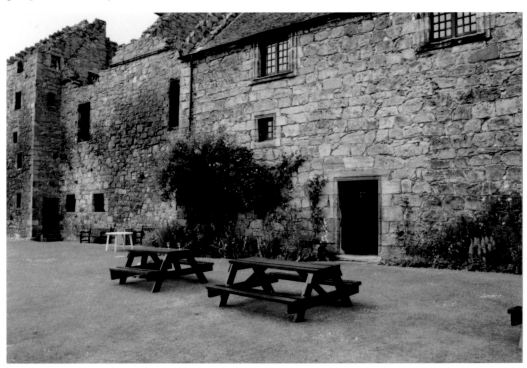

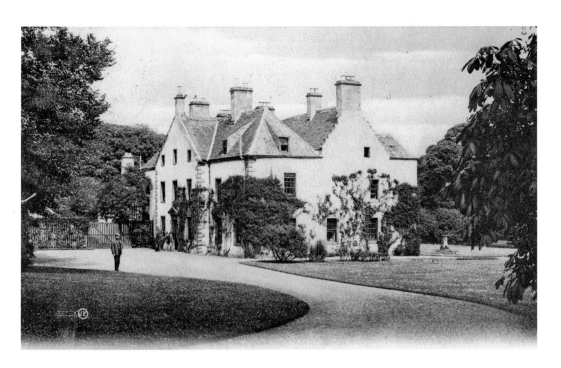

Aberdour House

Oddly enough, this 1904 card of Aberdour House was sent to New Aberdour in Aberdeenshire. The house, once a residence of the Morton family and occupied by Admiral Beatty, who commanded the Grand Fleet when based in the Forth in the latter years of the First World War, was converted into flats in the 1990s as part of the Earls Gate development.

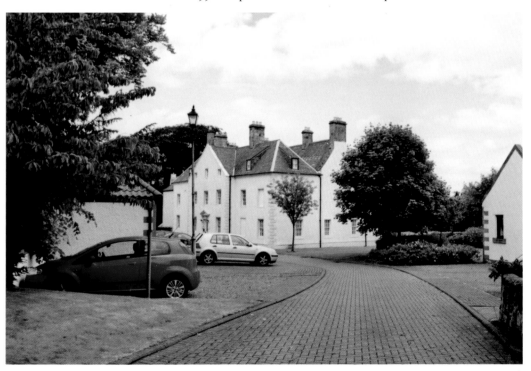

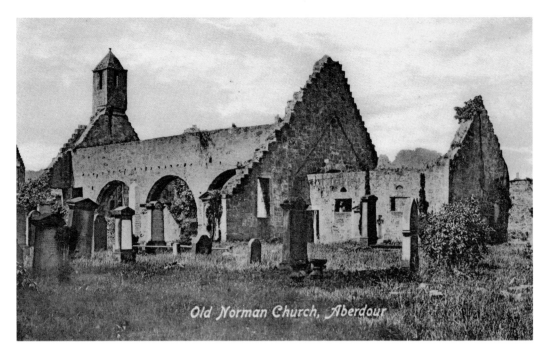

Old Norman Church, Aberdour

St Fillans Kirk

As a picturesque ruin, St Fillans Kirk featured in many postcards. Out of use since the 1790s, it was replaced by a more commodious building which was converted into the church hall after St Fillans was restored in 1926 through the generosity of the Laurie sisters of Starley.

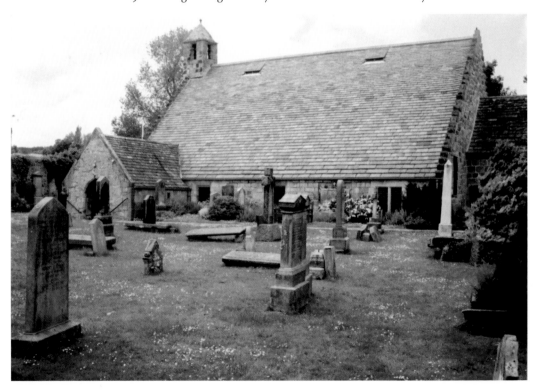

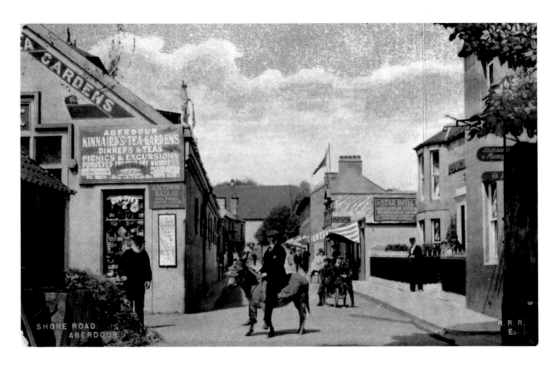

From Tea Garden to Institute

Kinnaird's Tea Garden, as well as selling meals, housed visitors in hammocks slung from the roof. A Forces canteen during the First World War, it then became the Village Institute. It also housed 'gentlemen boarders' and provided baths for locals with no bathrooms. After being a Forces canteen again during the Second World War, it was renovated post-1945. John McLauchlan's Star Inn (now the Cedar Inn) is on the right.

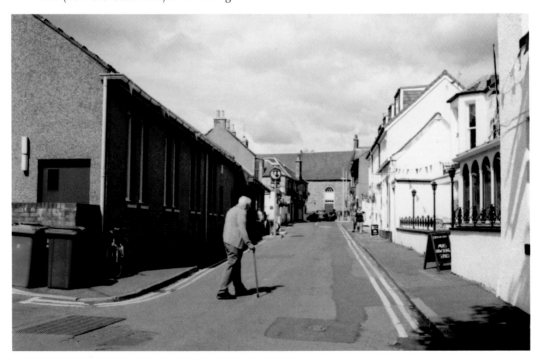

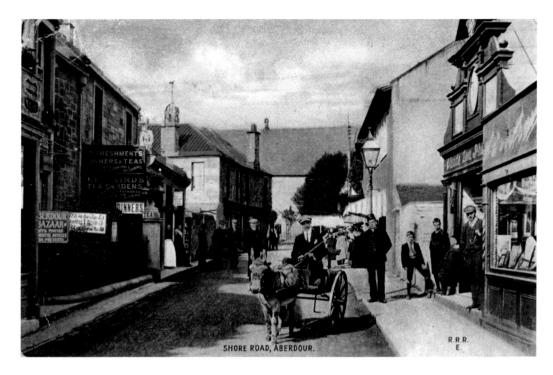

SHORE ROAD, ABERDOUR.

R.R.R.
E.

Donkey on Parade

Is the donkey seen here and in the previous image a stuffed one – a prop for Claud Low's photographic studio, the building on the right with the ornamental façade? At Kinnaird's Tea Garden, tea with ham and eggs cost 1s 3d. But observe the ghost-like figure on the roof.

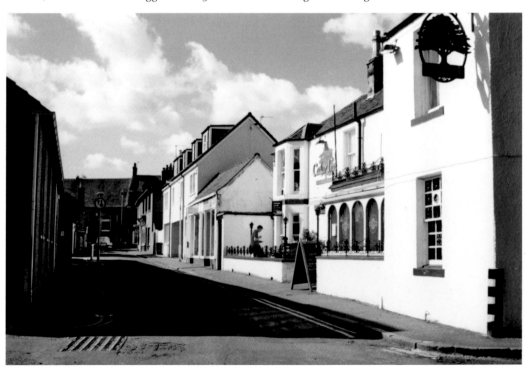

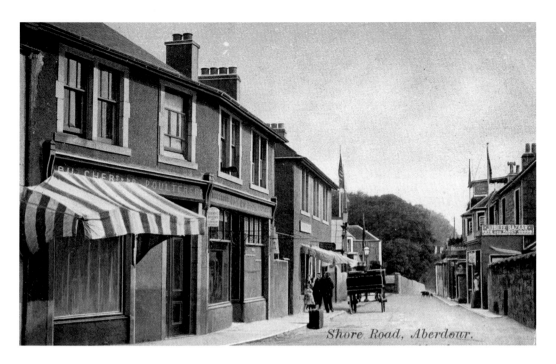

Shore Road, Aberdour.

Shore Road I

On Shore Road in the early twentieth century there were shops like Niven's the butcher selling foodstuffs, unlike now when they are all gift shops of one kind or another or eating and drinking establishments. They had gift shops then, too, but there were a variety of other shops as well. Horse-drawn delivery vans were another feature of those days.

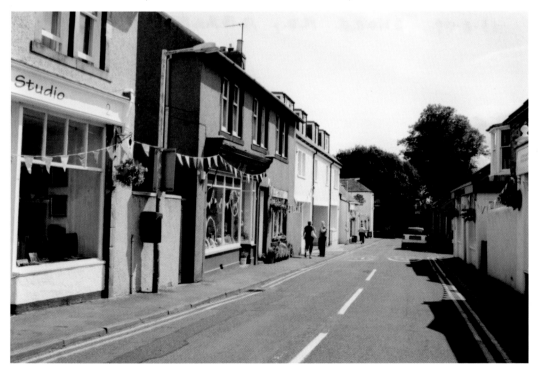

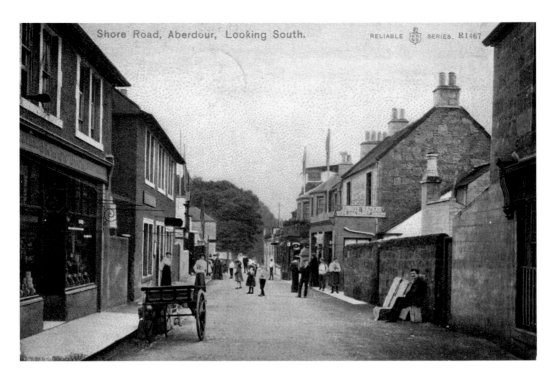

RELIABLE SERIES. R1467

Shore Road II

With tourists coming from and going to the steamer piers, Shore Road provided retail opportunities for street traders. The part of the wall this trader is sitting against has been replaced by a house sales agency. Wheelbarrows, like the one opposite, were commonly used for transporting goods, e.g. to and from the railway station.

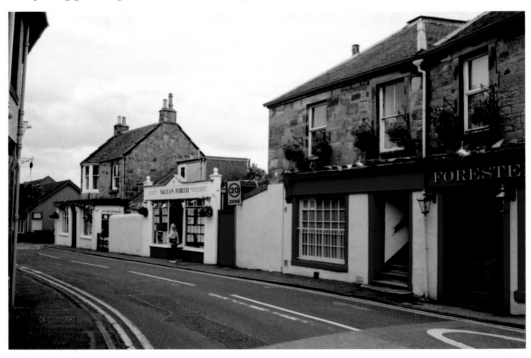

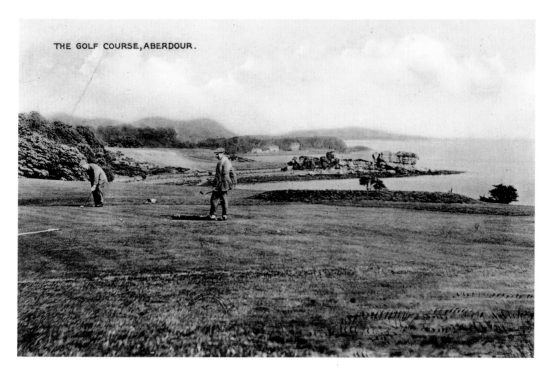

THE GOLF COURSE, ABERDOUR.

Golf Mania

Maureen, writing this card in April 1935, was having a nice holiday. She quotes Daddy as saying 'it rains everywhere but the golf course'. As in my 1984 image, photographed on Regatta Day, the Bell Rock is still intact.

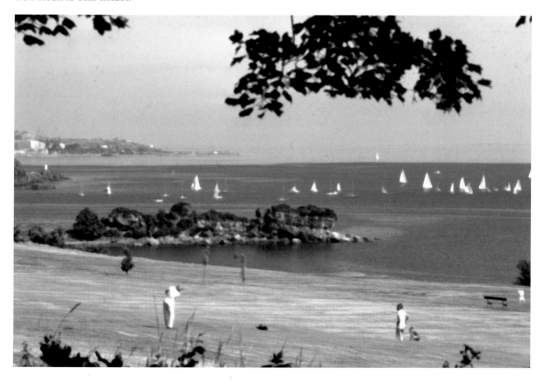

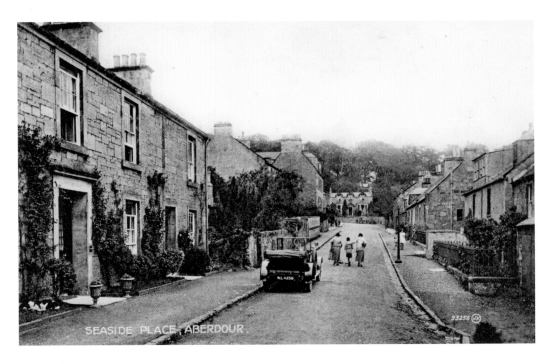

Behind the Scenes

Two lady golfers and, as on the previous page, a solitary car feature in this 1924 image of Seaside Place. Behind the smart 'New Town' houses there are some old-time survivals like these mini-buildings which once housed, from left to right, a toilet, a shed, washhouse and coal shed.

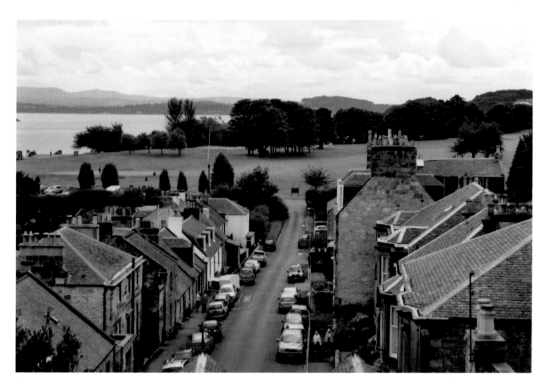

Seaside Place

Again, my image of Seaside Place looks in the opposite direction. The golfers in the old (1938) postcard are heading towards the golf course. The couple on the left are David and Evelyn Simpson (no relation to the author). David was the club professional and his shop was on the extreme right.

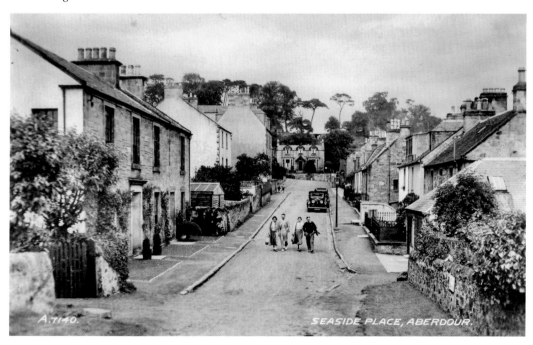

A.7140 SEASIDE PLACE, ABERDOUR.

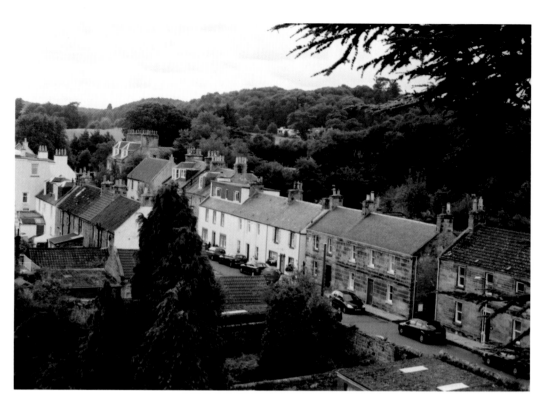

Manse Street

Manse Street was part of the 'New Town', on land feued from the Earl of Morton. My contemporary image is looking the opposite way as it shows the manse (built in 1802) to which the street owes its name. In 1871, the then incumbent, the Revd George Roddick, got into trouble with the kirk authorities for letting the manse to 'tenants, strangers, sea-bathers, and others.'

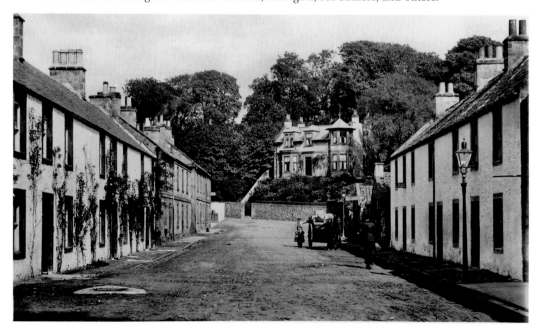

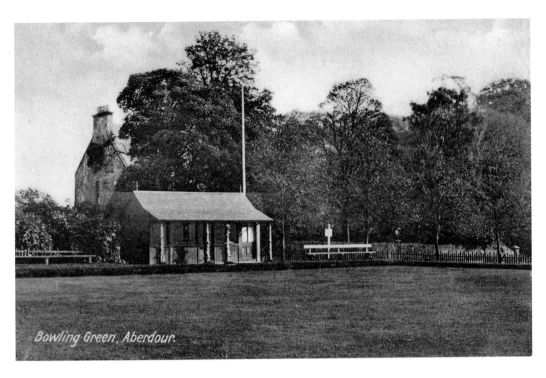

Bowling Green, Aberdour.

Bowling Mania
Today's bowling green pavilion reflects the game's contemporary popularity and today's more sophisticated needs.

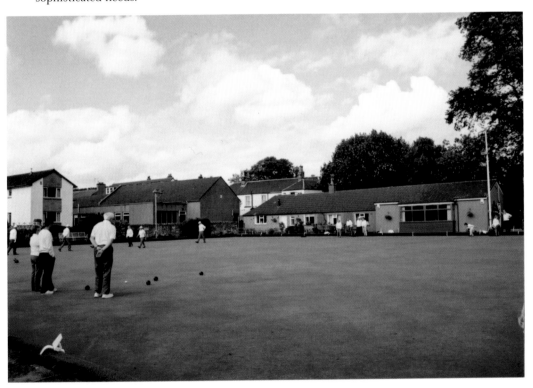

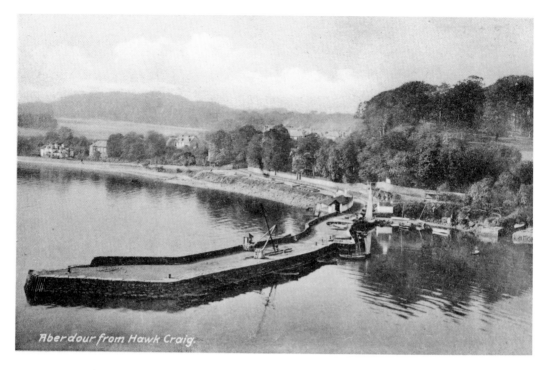

Aberdour from Hawk Craig.

Harbour Views

A strangely empty harbour and a heavily wooded sea front make a contrast with the contemporary scene. But in contrast to the new image, the old one was taken out of season, as you can tell from the line of rowing boats parked on the esplanade.

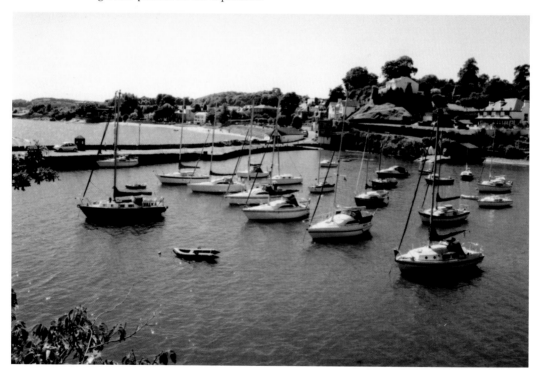

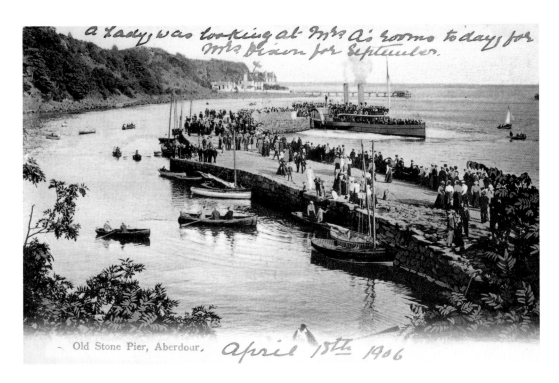

a Lady, was looking at Mrs A's rooms to day, for Mrs Dixon for September.

Old Stone Pier, Aberdour. *april 18th 1906*

Paddler and Rowers

Many of the trippers arriving on packed Galloway steamers hired a rowing boat. There are no rowing boats for hire anymore! But boats' dinghies were made available for the heats of the children's rowing competition during the 2010 Regatta. In former days, rowing events were incredibly popular and races were keenly contested.

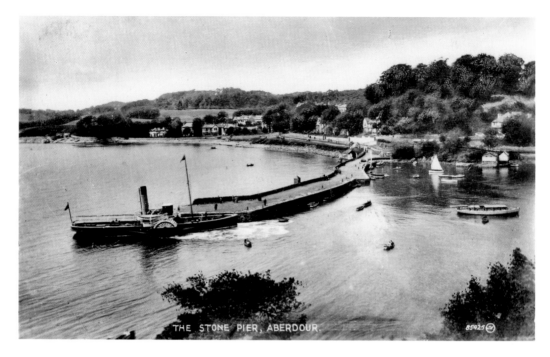

THE STONE PIER, ABERDOUR.

85925 (JV)

The Runner and **the Reaper**

The Grangemouth tug-cum-excursion steamer *The Runner* of 1921 makes a neat contrast with the *The Reaper,* the old Fifie sailing drifter tied up in Aberdour in May 2010. *The Runner* served as a tug through the week and carried trippers at weekends and on holiday occasions.

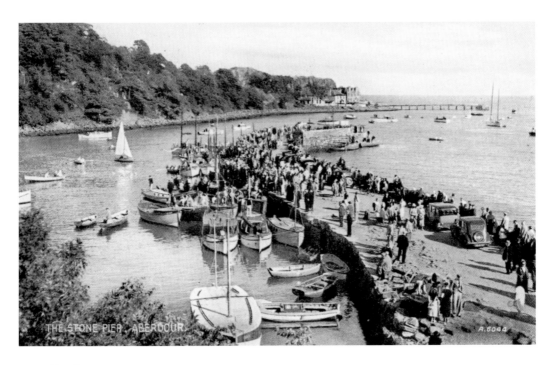

Pier Contrasts

On this summer day in 1937, the pier is packed and there are many different boats in and around the harbour, which suggests that it was probably a Regatta day. My July 2009 image shows a typical quiet day of the present time. But nowadays, motor boats have been replaced by yachts.

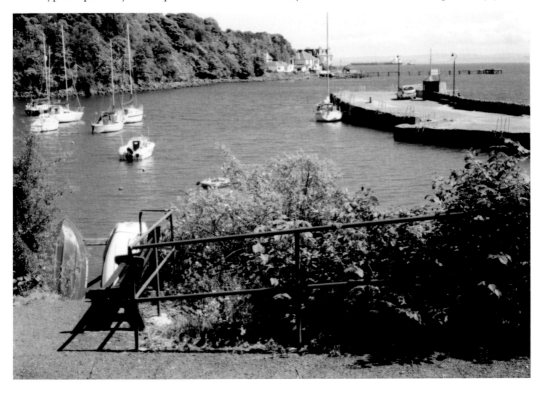

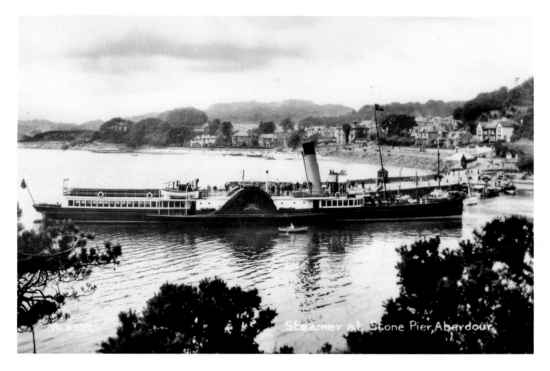

Fair Maid Farewell

Four years after this photograph was taken, the paddle-steamer the *Fair Maid*, with her band playing, left Aberdour for the last time. It was September 1939, the Second World War had started and this was the end of the great days of excursion sailings to and from Aberdour.

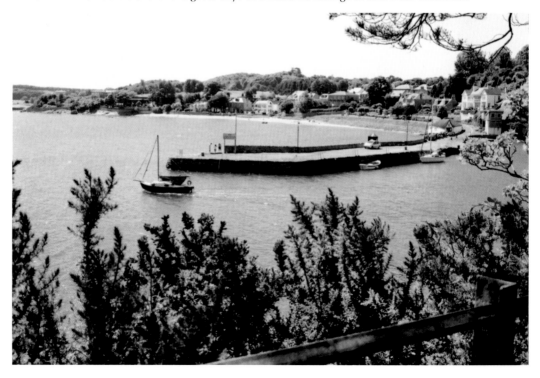

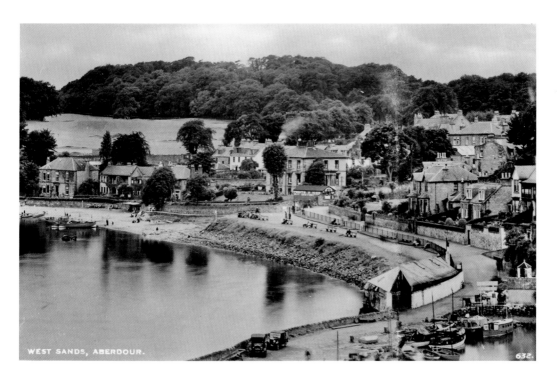

WEST SANDS, ABERDOUR. 632.

Buy British

In the 1930s, off Shore Road and adjacent to what was then Seabank House, we see a shop displaying in large letters 'Fruits & Ices', and below this 'Buy British'. One wonders where they got British oranges and bananas. Or is this a dig at Italian ice-cream sellers?

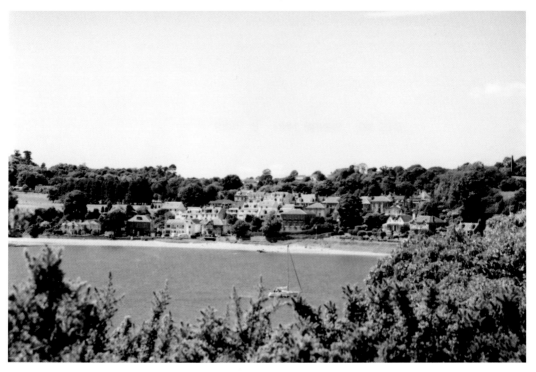

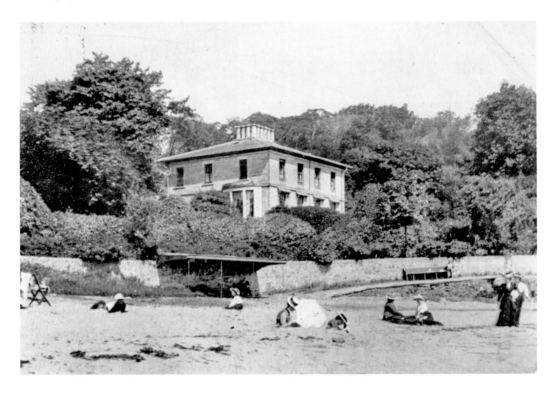

The West Sands
The writer of this Seabank House advertisement card posted in May 1912 wrote: 'It is quiet at present but woe whenever trippers come'. It was hardly peaceful on 7 August 2010 on Regatta Day either. But the youngsters were enjoying the sandcastle competition.

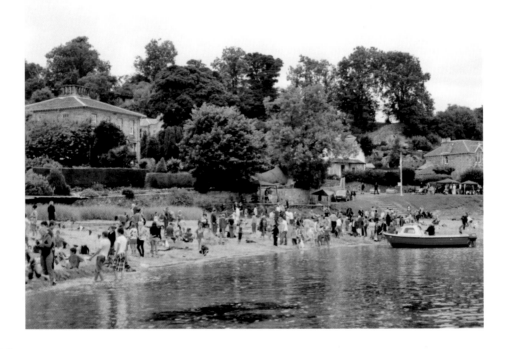

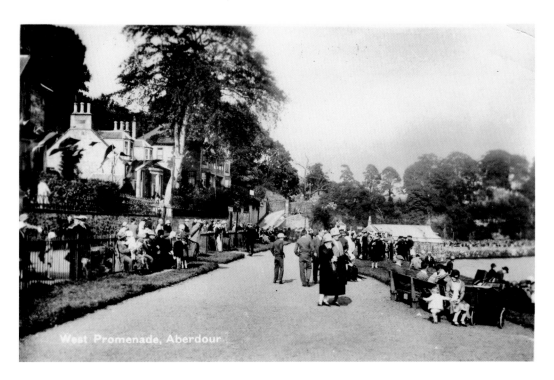

West Promenade, Aberdour

The Promenaders

While the prom was busy on Regatta Day 2010, in pre-war days the village could be even busier. Rowing and swimming races in the harbour, high diving from a platform, greasy pole contests and other fun and games entertained the crowds. People dressed more formally then for special occasions. The old postcard was published by W. T. Inkster, the Aberdour chemist at that time.

A Place of Rest

In Edwardian days, the prom was used not as a parking place for cars but for rowing boats. With snow on the ground, no one wanted to row round the harbour. Note the gas lamp standard, bench seats and covered shelter.

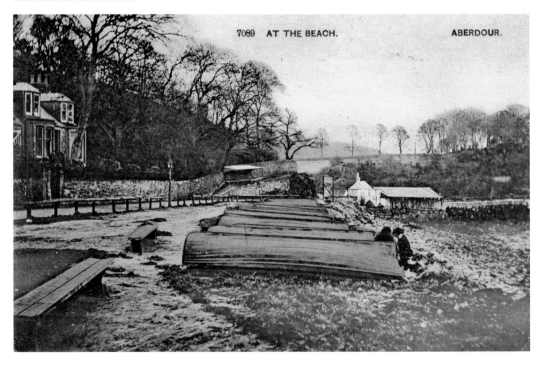

7089 AT THE BEACH. ABERDOUR.

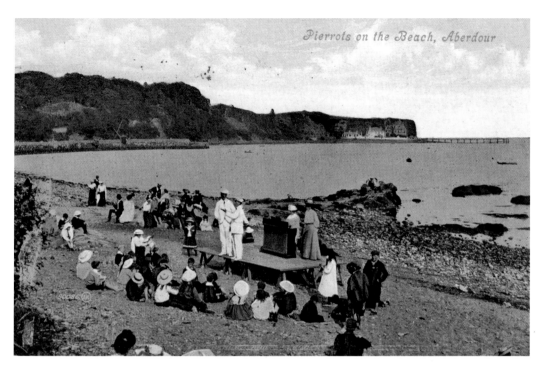

Pierrots on the Beach, Aberdour

All Agog!

When entertainers appear, children gather round. In the early 1900s, it was the pierrots making a skimpy livelihood out of al fresco shows on the Black Sands. On 9 July 1999, it was Scott Lovat, hired by Fife Council to mark the award of a prestigious Blue Flag for the Silver Sands beach.

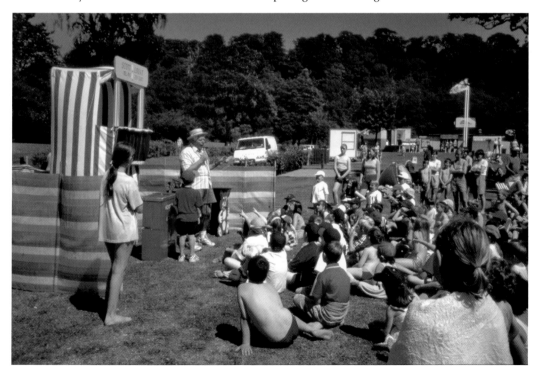

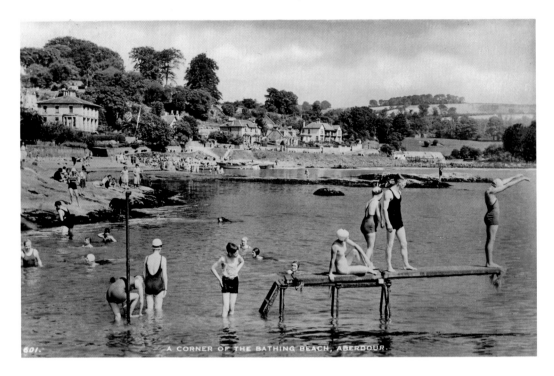

The Old Bathing Place

The sepia postcard was dated 13 May 1945, and the sender was enjoying the VE (Victory in Europe) Day Holiday in Aberdour. It was an old stock card, though, of pre-war vintage. Not so many people bathe from this end, or any other end, of the beach nowadays.

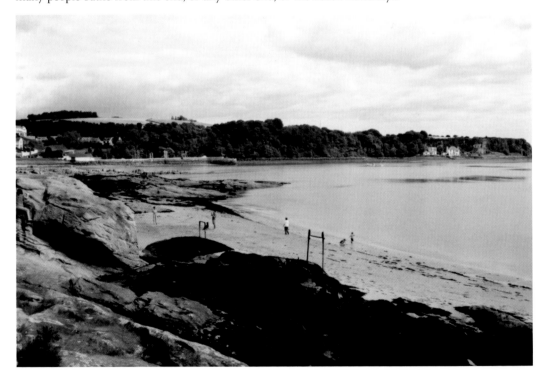

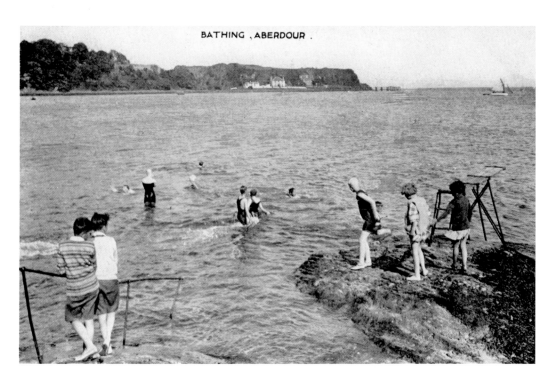

BATHING, ABERDOUR.

Dooking No More

More or less guaranteed warm weather on the continent and elsewhere has drawn holidaymakers away from the cold-water joys of the Fife Riviera. Rusted remains are all that are left of the diving board, likewise the railings that guided dookers down along stone-cut steps from the bathing shelter.

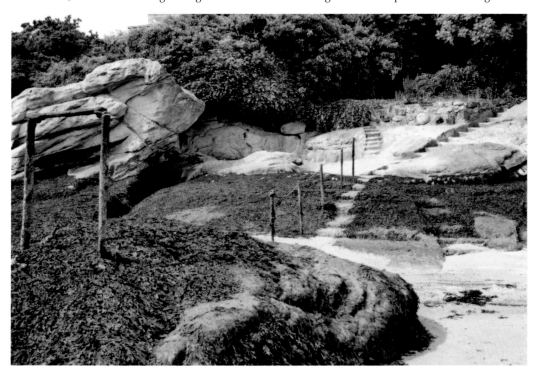

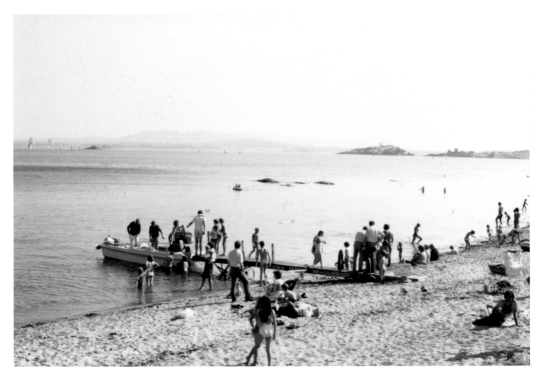

All Aboard!

Boat excursions from the Aberdour beaches, mainly to Inchcolm Island, were all the rage in pre-war days. Some boat owners maintained the tradition, as with this 1984 example, but for this service trippers now have to go elsewhere.

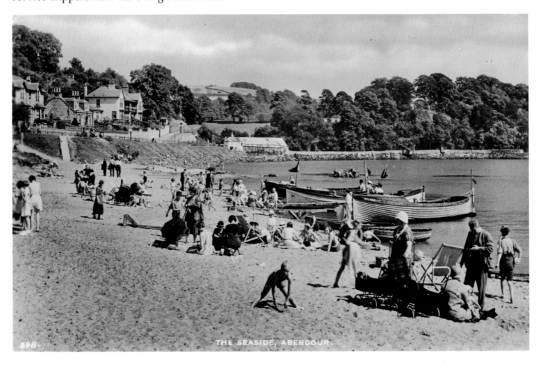

THE SEASIDE, ABERDOUR

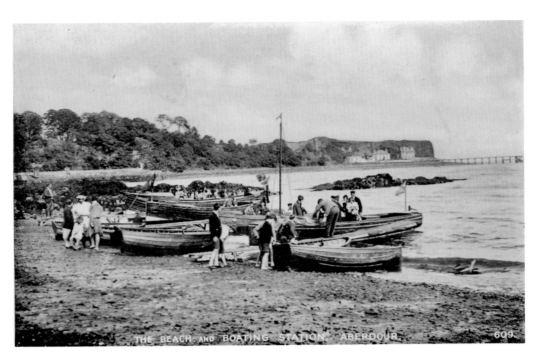

Raft Ahead

Here we have the boating station in very different eras. The modern era demands a rescue boat standing by at the start of the raft race during the 2010 Regatta. For the record, the race was won by the Room With A View crew.

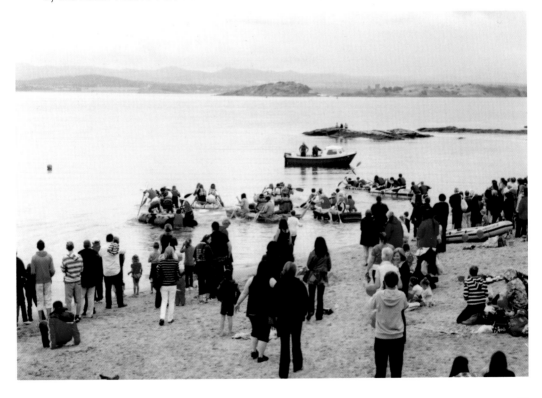

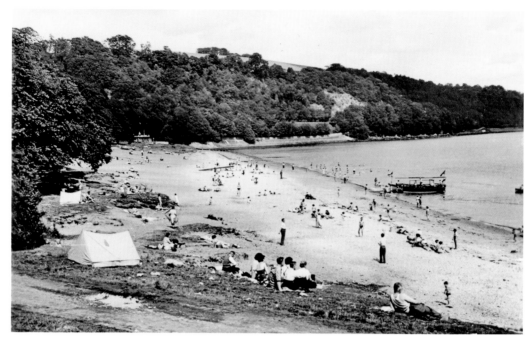

The Silver Sands

As in the 1930s, fine weather still brings out the crowds to the Blue Flag Silver Sands. The teahouse at the far end was burned down in the early 1940s.

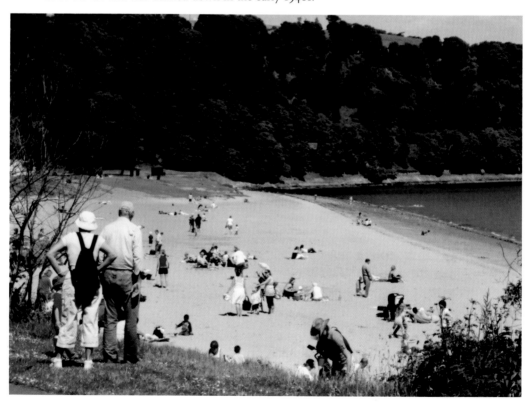

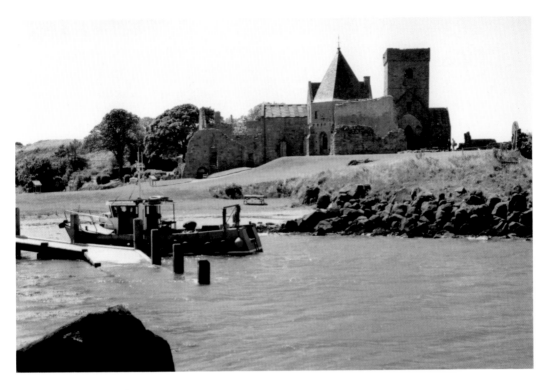

Offshore Island

Inchcolm Island, with its historic abbey, was the favourite destination for boat excursions. It was also a handy spot where local fishermen could tie up their boats to adjust their gear, both then and now. Today, though, the jetty is a big help.

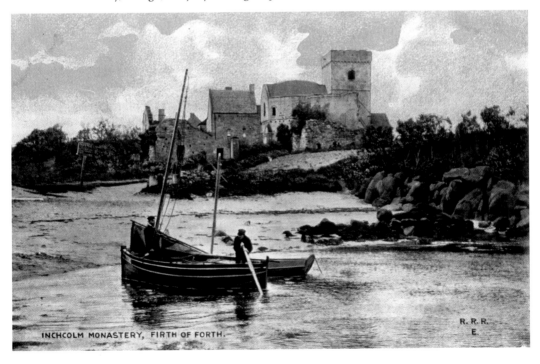

INCHCOLM MONASTERY, FIRTH OF FORTH.

R. R. R.
E.

43

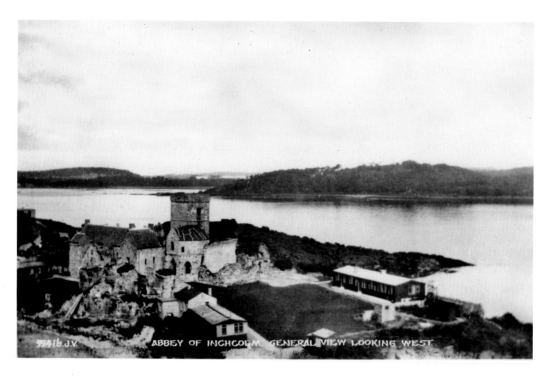

ABBEY OF INCHCOLM. GENERAL VIEW LOOKING WEST.

The Abbey at War

As a part of the Forth defences, the island was fortified during the two world wars – witness the two First World War military accommodation huts, which are long gone. Also, we can see that the chapter house must have been re-roofed during the interwar years.

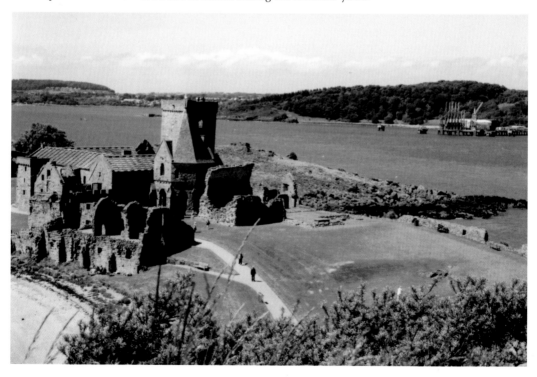

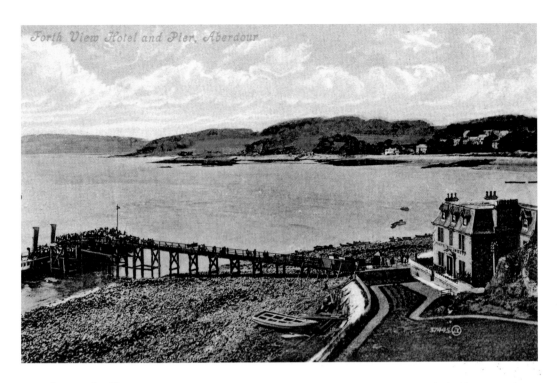

Forth View Hotel and Pier, Aberdour

Low-water Pier

The low-water pier built by Donald R. MacGregor in 1866 is now derelict, but the Forth View Hotel, with its Room With A View restaurant, is still going strong. It was the excursion steamer operator, Matthew P. Galloway, who built the house as a family home in 1881.

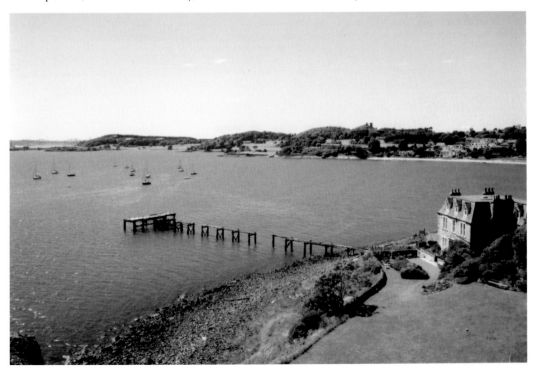

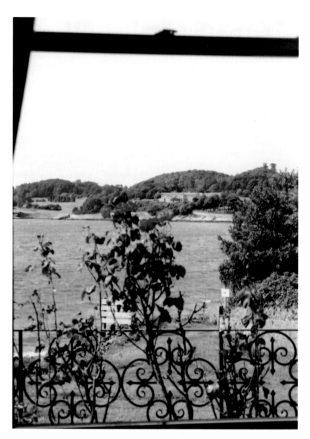

Hawkcraig View

Due to overgrown shrubbery it is difficult to replicate the Edwardian scene, and it is not just that we no longer see paddle steamers discharging their complement of day trippers. Accordingly, I have substituted a view from the interior of Room With A View.

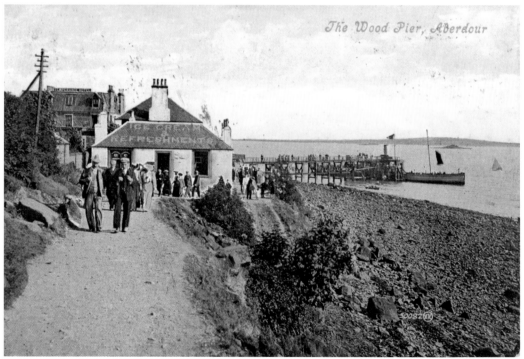

The Wood Pier, Aberdour

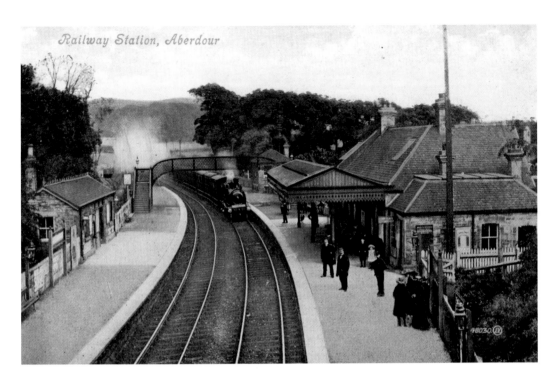

Railway Station, Aberdour

Steaming Through

One hundred and five years separate these two images, with the locomotive *Oliver Cromwell* being the more recent visitor – on 18 April 2010. The station was opened in 1890, the same year as the Forth Railway Bridge, and considerably boosted the number of visitors coming to Aberdour.

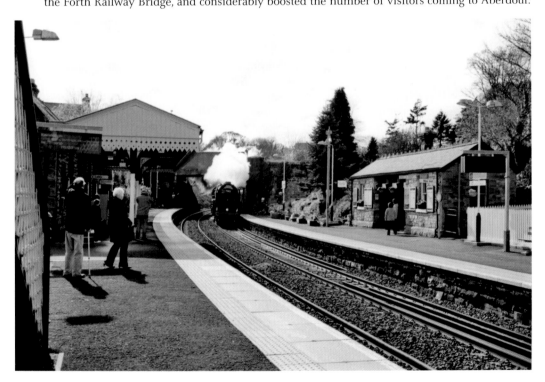

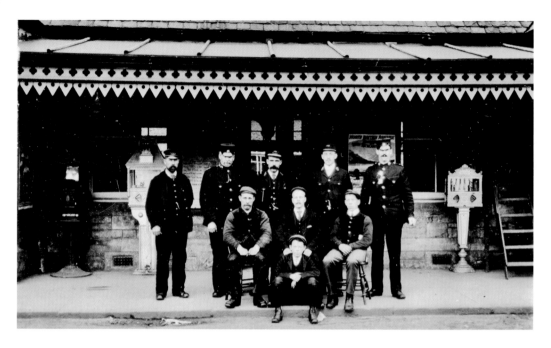

The Railway Men

A century ago Aberdour Railway Station was well staffed, even though their number was swelled by two stalwart bobbies. Today Trevor Francis, working there part-time, does it on his own and also manages, with volunteer help, to care for a very fine station garden.

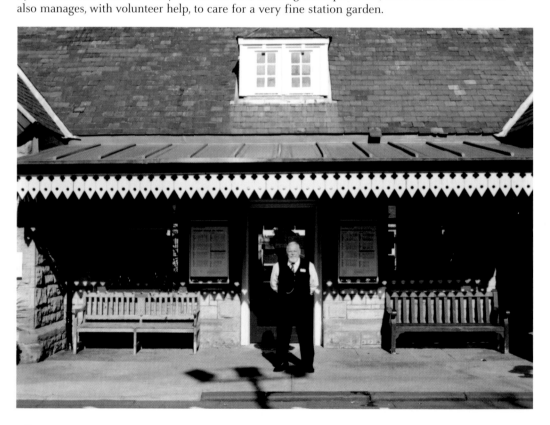

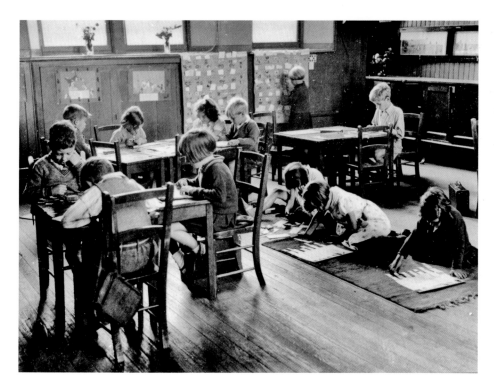

Group Methods

Who said group methods in primary schools were a 1960s innovation? The older photo was taken *c.* 1933 in the Aberdour infant department by class teacher Miss Catherine Watson, who was a pioneer in 'new methods'. In Dalgety Primary School *c.* 1970, they at least had desks that were more suited for group methods.

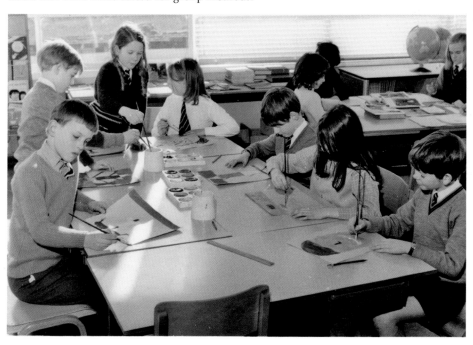

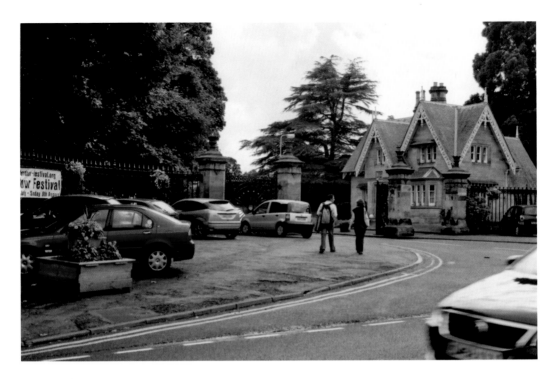

Donibristle Gates

Once, 'respectable' visitors to Aberdour needed a permit to see the grounds of the Earl of Moray's Donibristle Estate. We don't require that nowadays, so we are off through the imposing gateway, erected in 1870, to see the grounds where the new town of Dalgety Bay was built. We note in passing that the main central gates have gone.

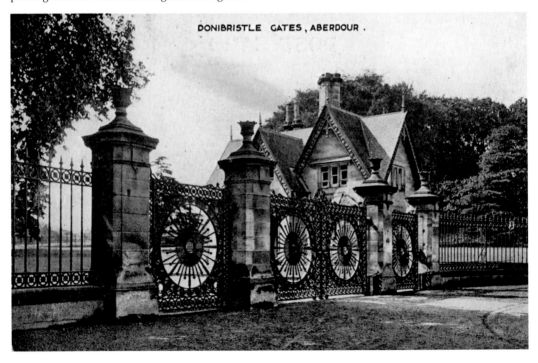

DONIBRISTLE GATES, ABERDOUR.

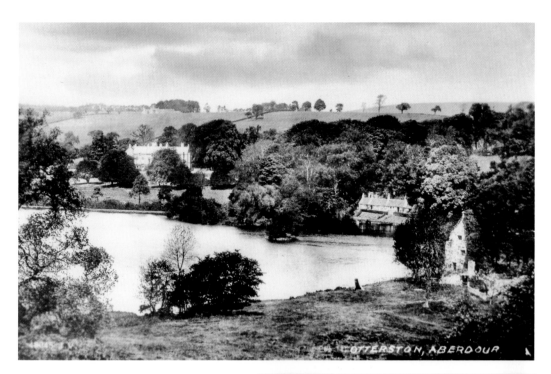

Otterston

First, though, we take a peep at local beauty spot Otterston Loch. Since 1905, though, Otterston House on the left has gone, with a replacement house on the site. Couston Castle, then just a fragmentary shell, as my 1987 image shows, was restored in the 1980s by local businessman Alastair Harper.

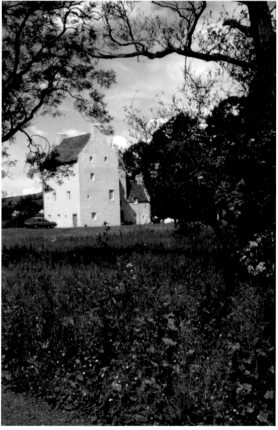

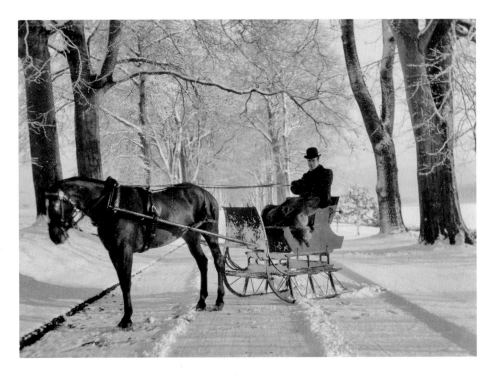

The Beech Avenue

Once through the entrance gates, we follow the Beech Avenue which led originally to Donibristle House, but now gives pedestrian and cycle access to Dalgety Bay. In *c.* 1900 Dr Charles Sturrock was using a horse-drawn sleigh to get around. Nowadays, snowdrops followed by daffodils provide a blaze of colour.

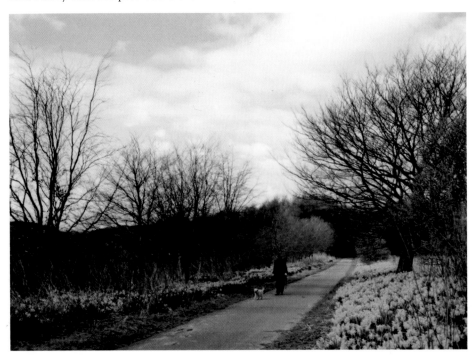

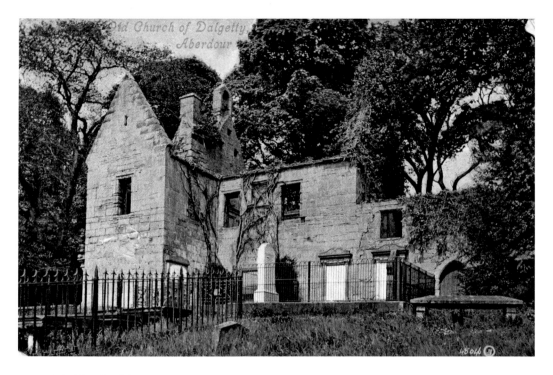

St Bridget's Kirk

A photographer from Valentines must have been touring the beauty spots of the area in 1905, as this image of St Bridget's Kirk is another of theirs of that date. While the railings have gone and some of the gravestones have fallen, the environs are kept neat and tidy by Historic Scotland.

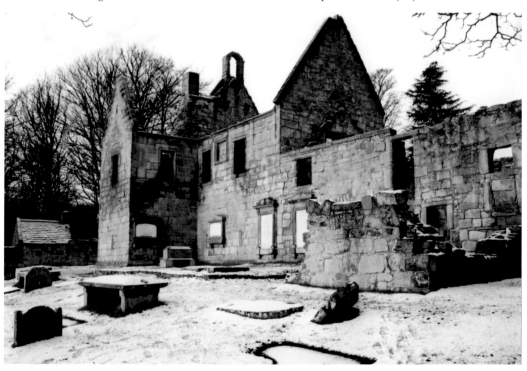

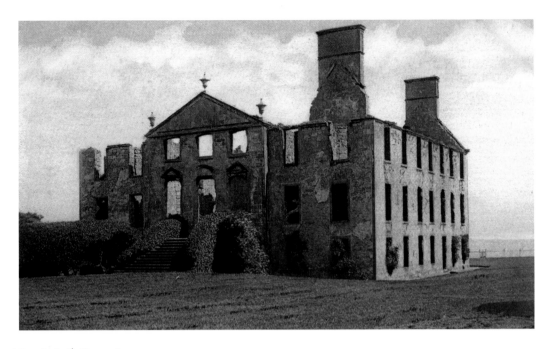

Donibristle House I

In 1858 the Georgian main block of Donibristle House was ravaged by fire. Never rebuilt, it was demolished in 1912. In 1989 Muir Homes purchased the site, which included the side wings, and built a number of dwellings, including, as we see, a block of flats somewhat resembling the original big hoose.

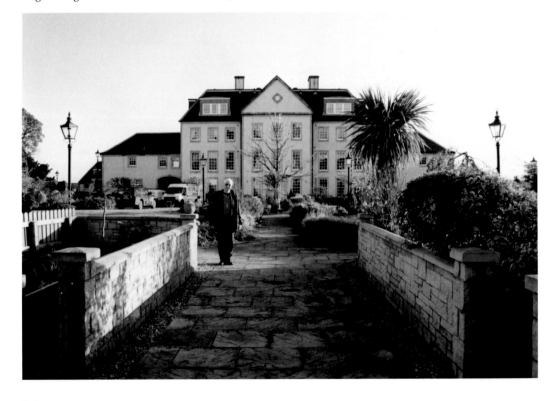

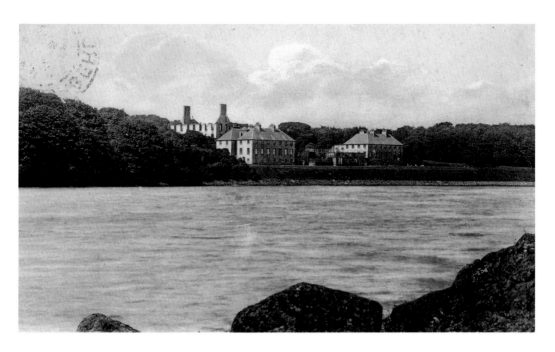

Donibristle House II

After the 1858 fire, the Moray family continued to use Donibristle's two wings, which were originally servants' quarters. During the Second World War, and afterwards till 1976, they housed high-ranking officers. Both wings and the ornamental ironwork dividing them were restored by Muir Homes Ltd in the early 1990s.

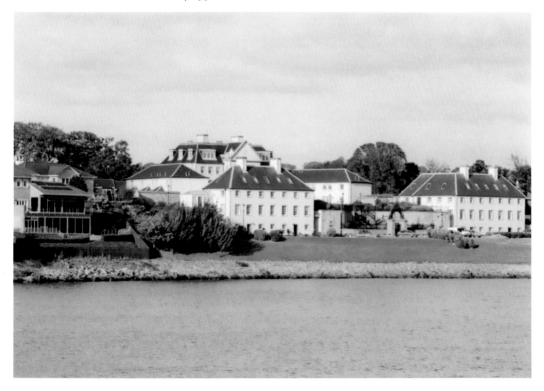

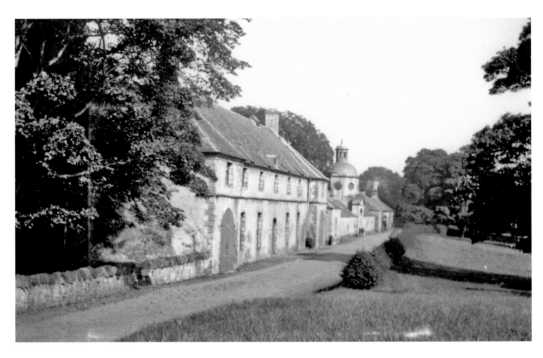

Stable Block

Estate buildings just to the west of the big hoose included a coach-house (now replaced by a bungalow) and, next to it, the stable block and then by a cottage, now gone. The stable block was converted into housing units by Muir Homes.

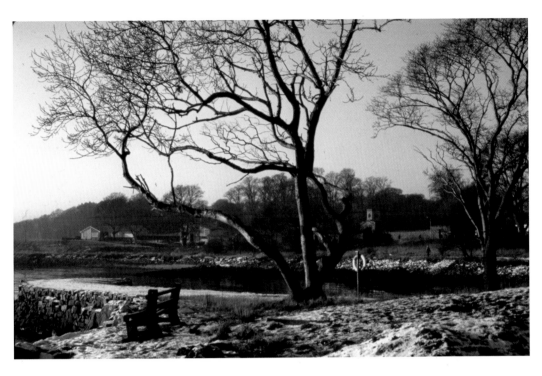

The 'New Harbour'

In 1984 the stable block was still ruinous, but the old 'New Harbour' in the foreground, which had once housed the Earl of Moray's yacht, had been repaired by Boat Club volunteers.

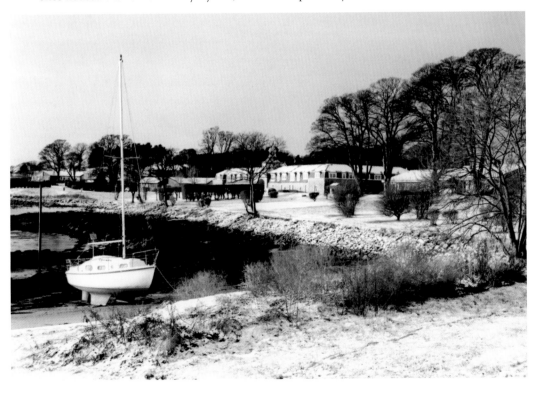

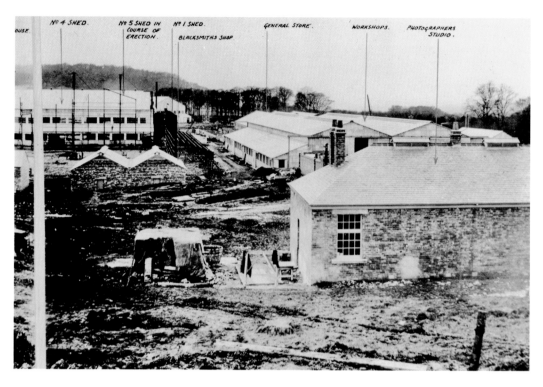

NO 4 SHED. | NO 5 SHED IN COURSE OF ERECTION. | NO 1 SHED. | BLACKSMITHS SHOP | GENERAL STORE. | WORKSHOPS. | PHOTOGRAPHERS STUDIO.

The Airfield – Early Days

A series of photographs were taken in December 1918 when Donibristle air station was under construction. One survival from that time is the photographers' studio on the right. The building survives as part of a children's nursery, the twin chimneys being the giveaway.

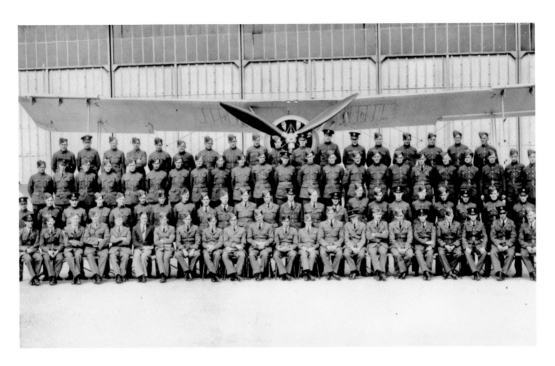

Donibee from Peace to War

Until 1939, Donibristle (Donibee) air station was in the hands of the RAF, as witness this 1936 photograph of personnel of 42 (Torpedo Bomber) Squadron. In 2003 wartime pilot Lieutenant-Commander Tony Shaw MBE unveiled a monument in the shape of a Spitfire wing. Its purpose was to commemorate all those, civilian and military, who had ever worked or served at Donibee.

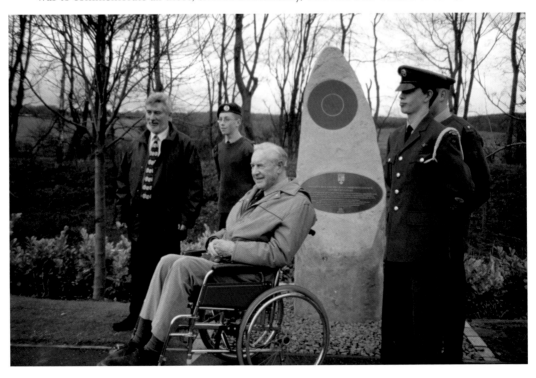

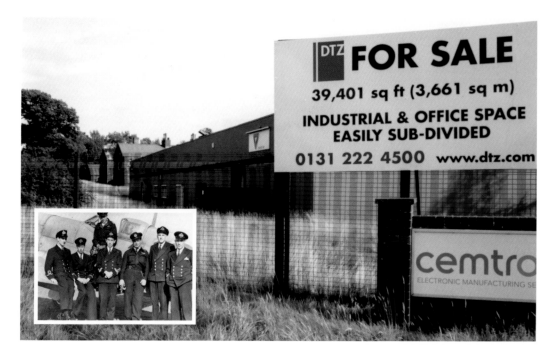

Navy Days

In 1939 the airfield was handed over to the Royal Navy as a Fleet Air Arm base. The officers' quarters were in the brick building to the left of what is now a factory complex. On the walls of a storeroom, some artistic matelot painted a frieze poking fun at life and work in a naval air base. All the characters are depicted, except for their headgear and insignia of rank, in the garb of ancient Egypt. The insert shows a group of Navy pilots at Donibee in 1944.

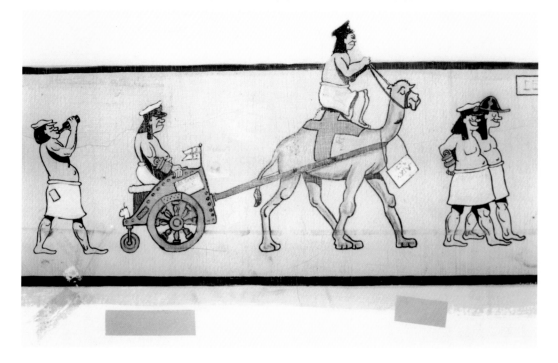

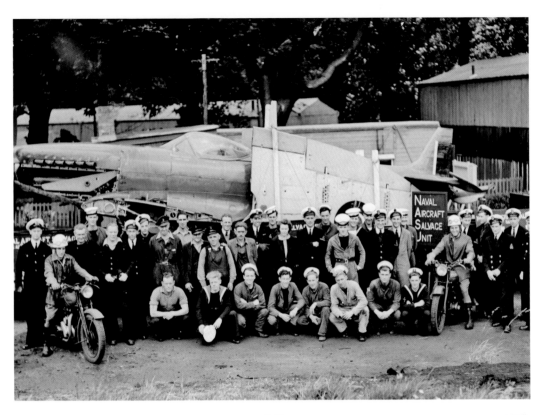

Radioactive Legacy

Donibristle also embraced an aircraft repair yard, which included repairing salvaged aircraft. Aircraft that were beyond repair were broken up in a corner of the bay. Unfortunately, these included control panels containing radium – a legacy which necessitates regular examination of that part of the foreshore for radioactivity, as photographed here in December 2009.

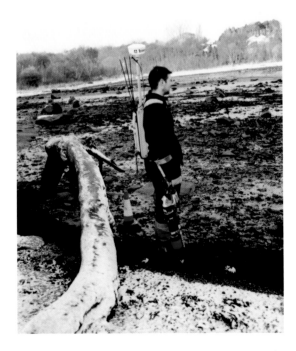

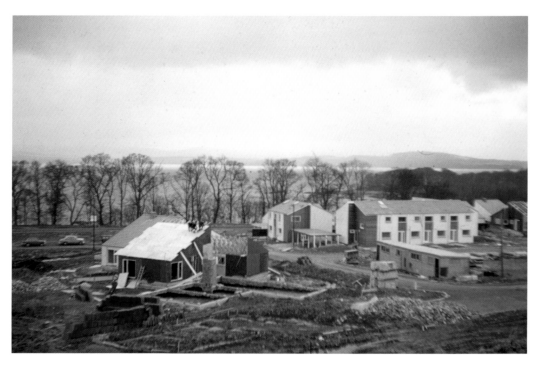

Dalgety – Early Days

Frankfield Road was one of the first parts of the new town to be built. The house under construction on the left was the author's home when he and his family moved to Dalgety Bay on 5 May 1966. Not much has changed in that quarter of the town.

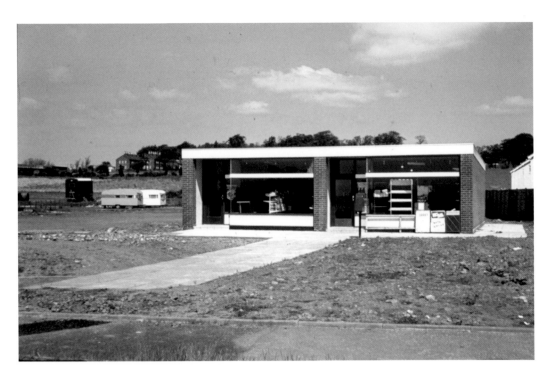

East End Shops

The first shops to be built in the new town were photographed by George Hastie in June 1968. That block has since been extended. The railings protect the underpass, a feature popular with planners of those days.

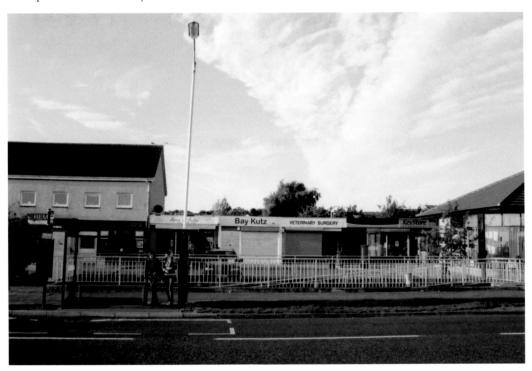

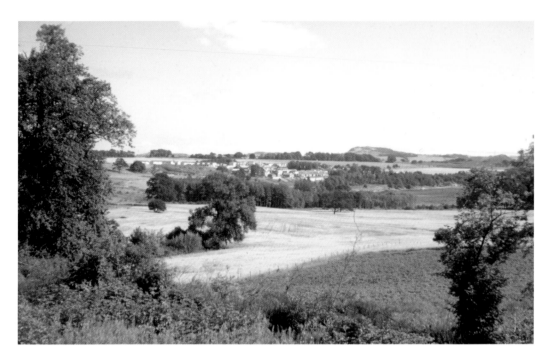

Village No More

In 1969 I photographed the tiny village which was all that Dalgety Bay amounted to then from what is now Longhill Park. The slopes of the park, as snapped in December 2009, now serve as a great place for sledging.

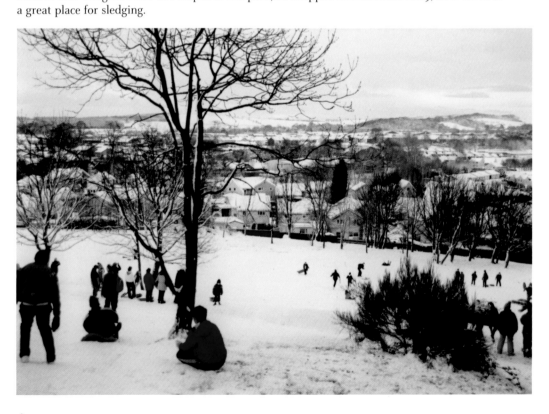

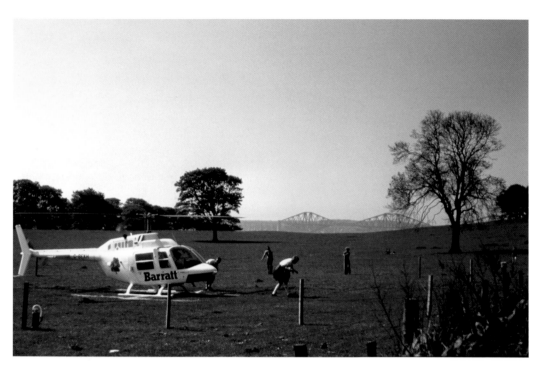

The Barratt Chopper

On 18 May 1980, the Barratt helicopter, with celebrity guests on board, landed on a piece of empty land off Moray Way South.

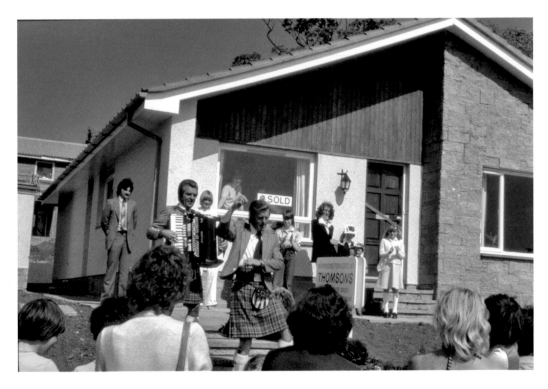

Celebrity Fling

The celebrities off the chopper were singers the Alexander Brothers, and they were there to open a new Barratt show house on their Etive Place development.

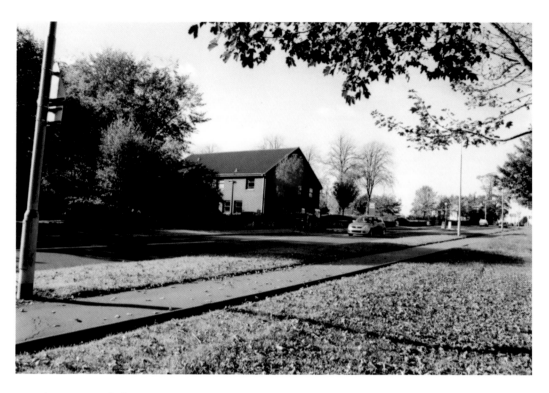

Regent Road Changes

Since the seventies, the wall north of the Police Station that surrounded the former kitchen garden of the Moray estate has been reduced in height at the Regent Road side. As a garden, the site had been well chosen as it had been prime agricultural land.

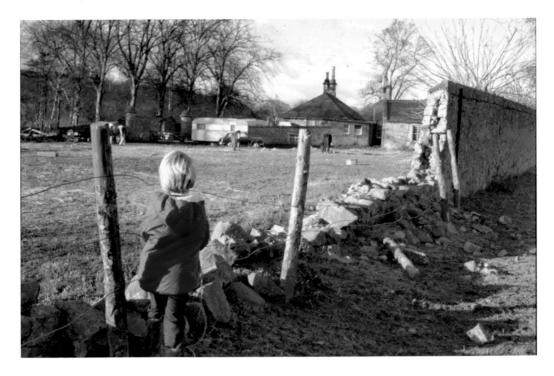

Old Kitchen Garden

Peeping through the broken wall on Christmas Day 1975, we were able to see the gardener's cottage and, to the right of it, part of the bothy which housed the assistant gardeners. Tesco Metro and other shops now occupy most of that space. Willie Mills (inset), who farmed the land that lay outwith the airfield and lives in the former gardener's cottage, still treasures his 1976 Massey-Ferguson tractor.

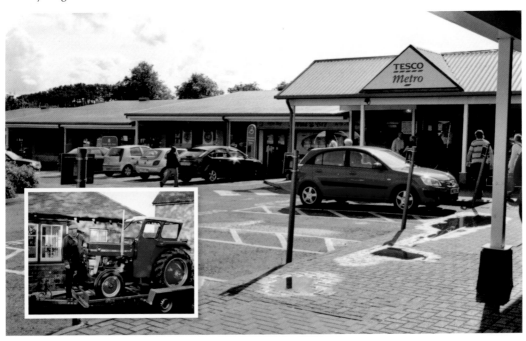

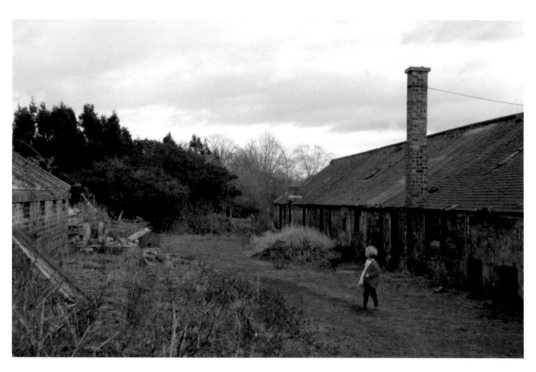

Greenhouses No More

On Christmas Day 1975 I wandered about with a camera, photographing buildings that were due to go, including the partially ruinous former estate greenhouses. The library and clinic now fill the space.

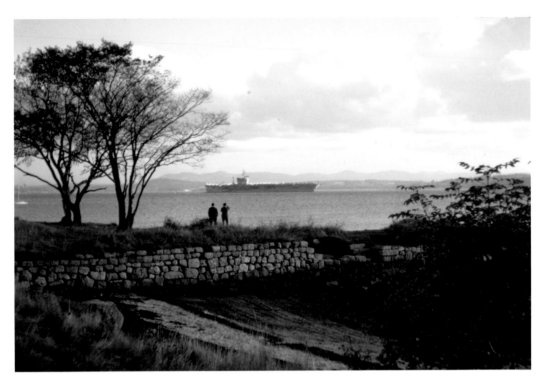

Shipping Contrasts
When, in September 1973, the 83,000-ton US Navy aircraft carrier *John F. Kennedy* lay at anchor in the Forth, the 'New Harbour' had yet to be restored.

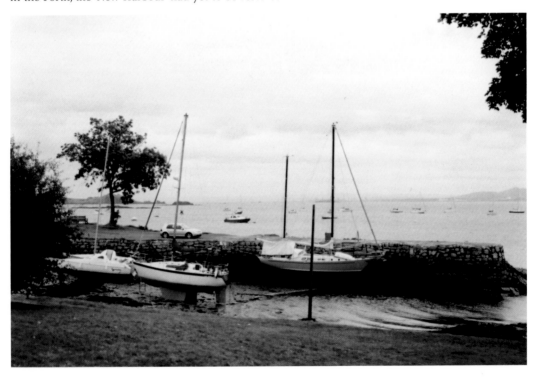

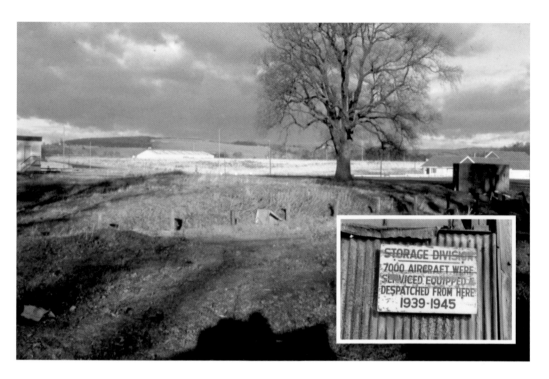

Community Care

In 1975 the Community Centre was newly built, but it was six years later before the kirk was built. The wartime pillbox has gone, though. The notice (insert) on a long-demolished hangar sums up the achievement of the thousands of men and women who worked at the aircraft repair yard.

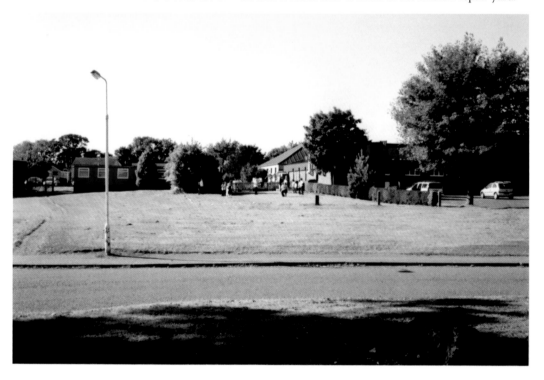

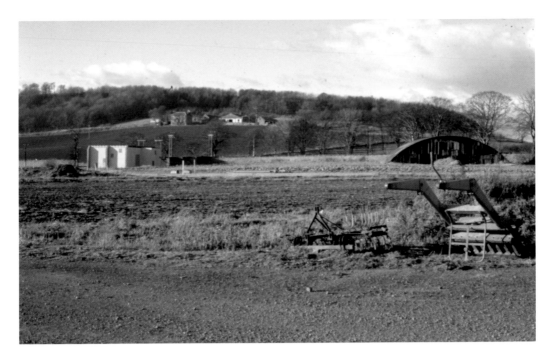

Airfield Remnants I

It is not always possible to match old and new exactly. One common element in these images is the former aeroplane engine test bed building on the left, as snapped in 1975. By then it had been adapted as an electricity sub-station. Now, as seen from Moray Park and partly hidden by trees, the enlarged building is on the right of the other image.

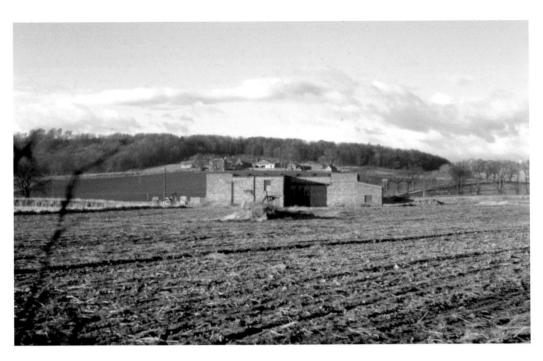

Airfield Remnants II

In my 1975 image the Letham Farm buildings are visible just below Letham Hill woods. By 2009 only the former farmhouse remains, the roof just keeking above the trees.

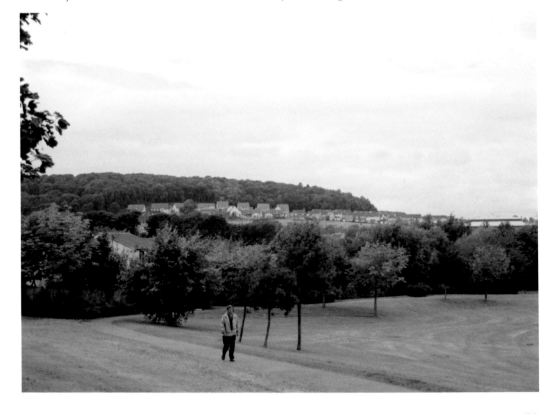

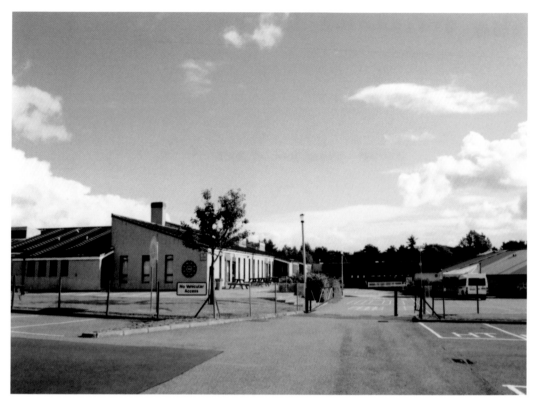

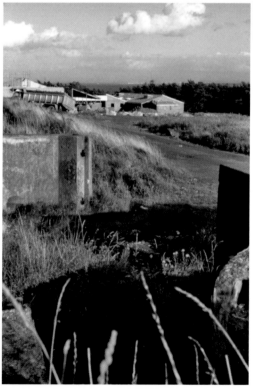

The New School
In 1978 Donibristle Primary School was being constructed, with the relics of an anti-aircraft battery still in the foreground. The 'Attery' stood nearby, providing accommodation for the female service personnel of the ATS (now WRAC) who helped man the guns.

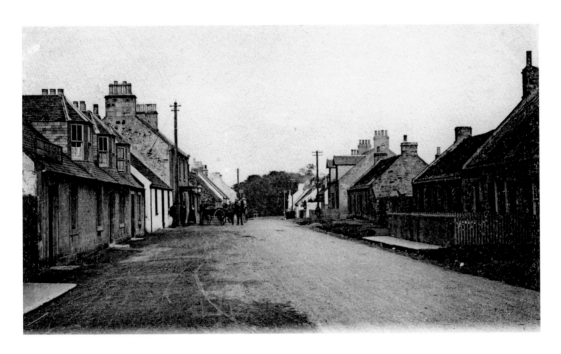

Hillend from West

Maud, the sender of this Hillend card posted from Crossgates in 1904, had been down a mine that day. 'It was such fun,' she wrote! Hillend she described as quite close to Fordell, so it was presumably one of the Fordell pits she descended. Not much fun for those who laboured there all the time.

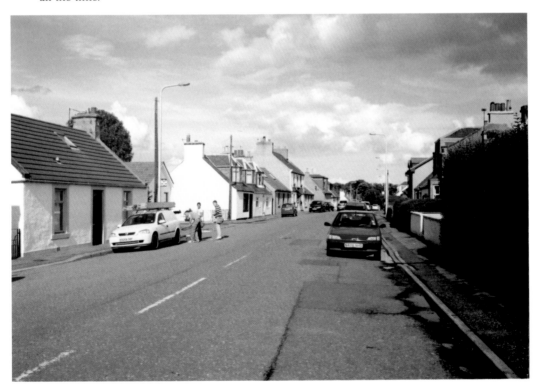

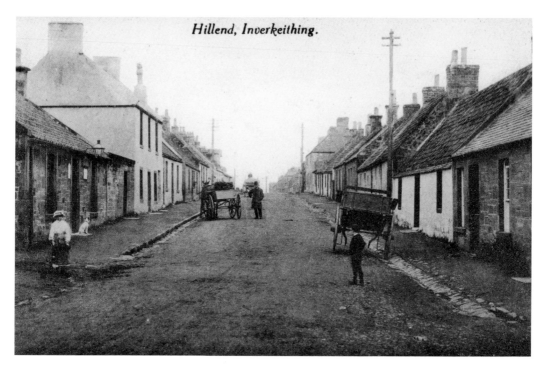

Hillend, Inverkeithing.

Hillend from East

Hillend, looking west this time. In the early twentieth century, the post office was in the building with the lamp attached. Motor cars in those days would have been a rare sight.

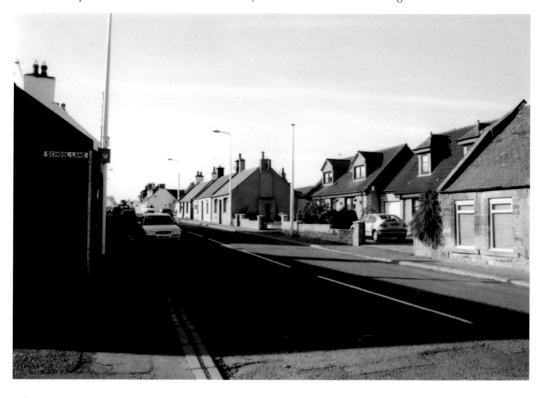

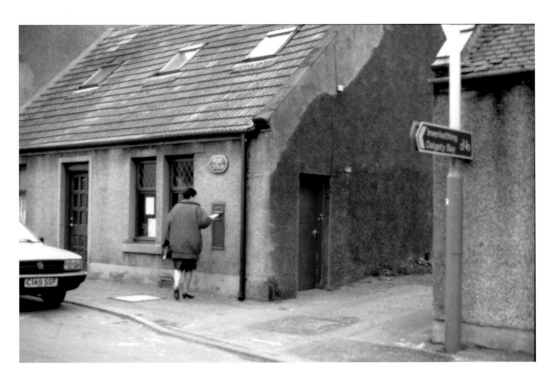

Post Office and Tavern

I photographed the post office on that site the day before it closed on 1 December 1994. Fortunately, the licensee of the Hillend Tavern offered space at the back of their premises for postal services. Now that, in its turn, has been closed. The pub proprietors, Ricky and Linda Nobile, were snapped right where the letter box used to be.

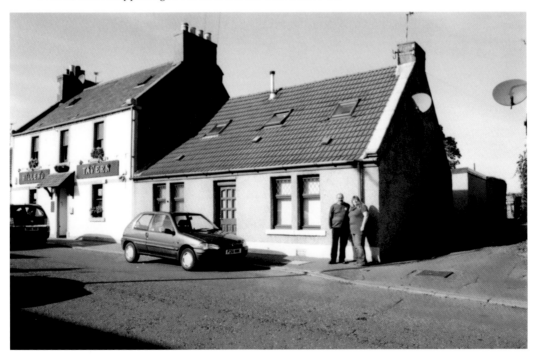

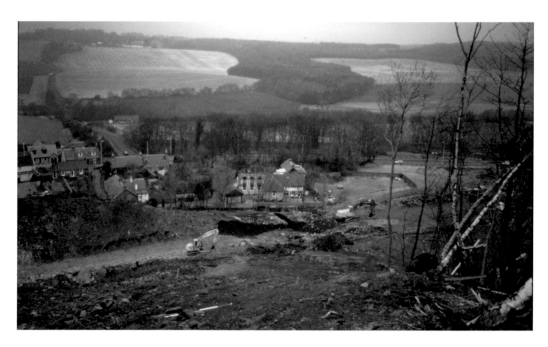

Hillend Bypassed

In February 1993 the Hillend bypass was still under construction. On 21 June 1993, villagers cheered the first vehicles to pass along the new road. They also had a party that day to celebrate the occasion.

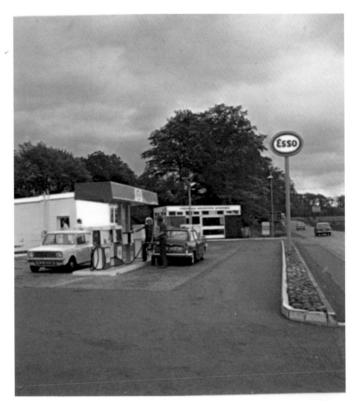

Stations Old and New
There were once two filling stations at the west end of Hillend and one at the east end – namely Forsyth's Hillend Service Station, as photographed for a sales brochure in 1973. The railway station car park has taken over this space.

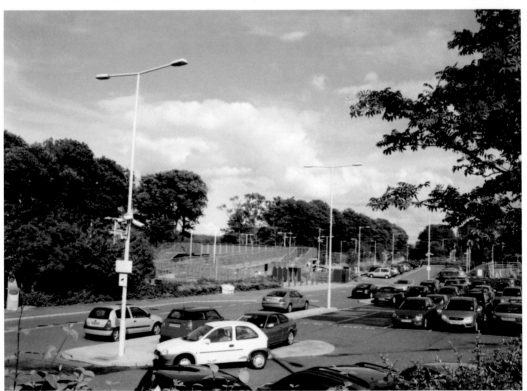

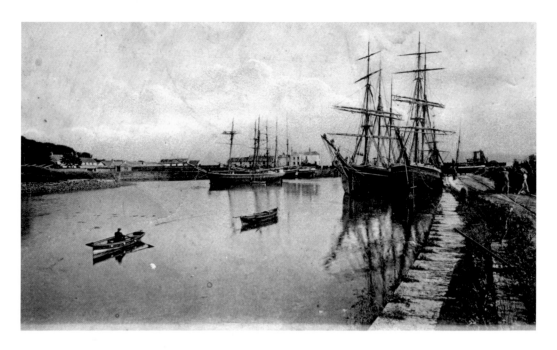

St Davids Harbour

The view from the south pier at St Davids has changed out of all recognition since its Victorian heyday. Colliers then were in the harbour waiting to be loaded with coal. On the extreme right, two workmen are pushing a ballast wagon along the pier rails.

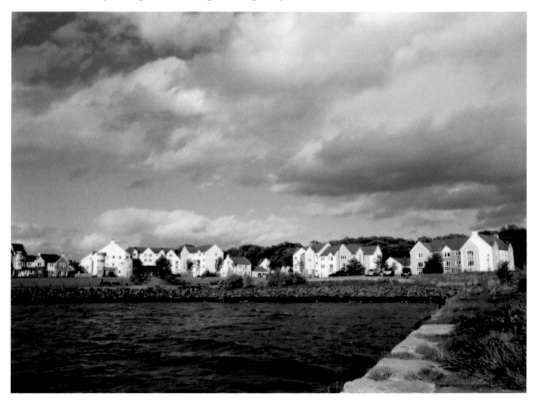

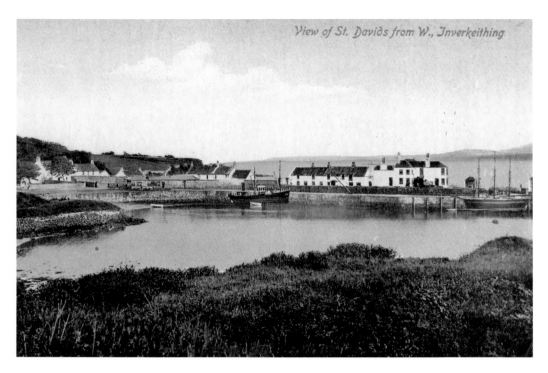

View of St. Davids from W., Inverkeithing

St Davids Harbour II
With its red pantile-roofed dwellings, St Davids was a picturesque wee port and the developers have tried to retain some of the ambience – without the coal dust of course.

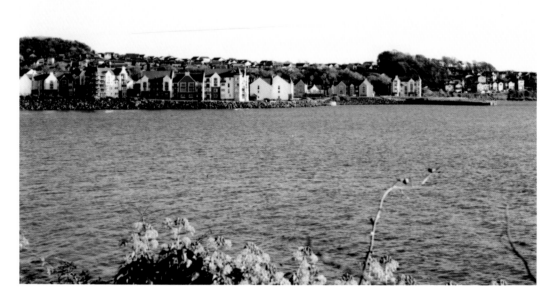

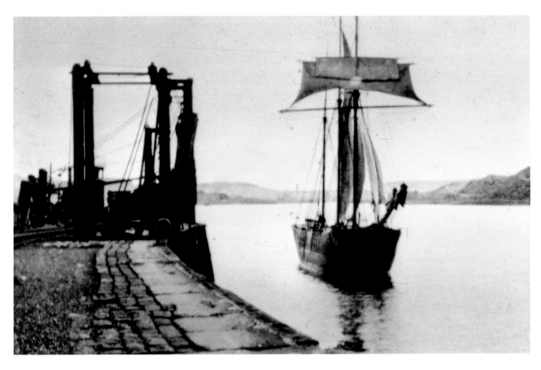

St Davids Pier

The most activity the pier sees nowadays are youths fishing there, quite a contrast with this scene *c.* 1930, where we see an empty collier passing the coal hoists. The harbour was the outlet for coal from the Fordell pits, delivered down the historic railway.

The Last Load

On 10 August 1946, the puffer *Cuban* took on the last load of coal, photographed here by Napier S. Landale, the General Manager of Fordell colliery. The coal wagon is being tilted to shoot the coal into the puffer. An anchor, the piers, and some street names are all that now remind us of St Davids maritime past.

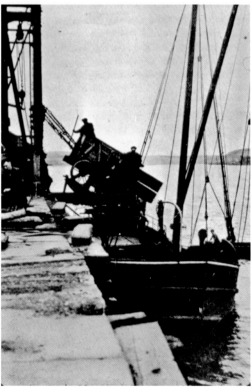

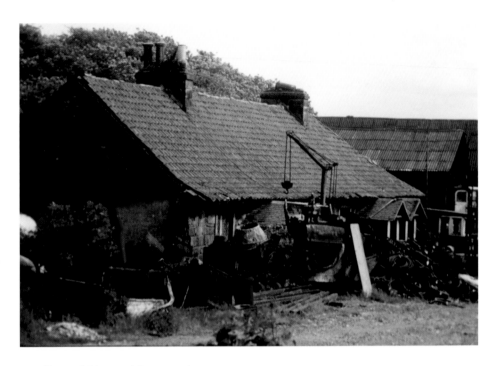

Pantiles and Diamond Panes

St Davids cottages were condemned in 1950 and most were demolished, though one or two survived for some years. But, standing in the middle of a scrap yard, they were unoccupied. Compare the empty cottage with the view, *c.* 1931, of Margaret Syme and granddaughter Lily at the door of their little home, complete with diamond-paned windows.

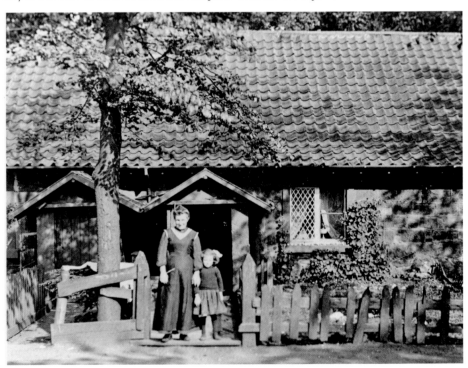

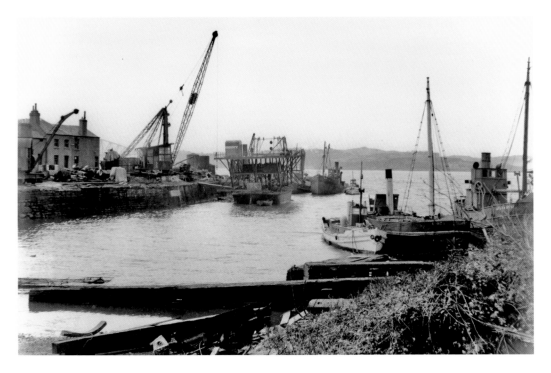

Breaker's Yard

Though St Davids no longer exported coal, there were still ships to be seen there. But most of them were there to be broken up. Around 1950, the National Coal Board was drilling for coal in the Firth of Forth. On the left we see a drilling rig being assembled by the south pier.

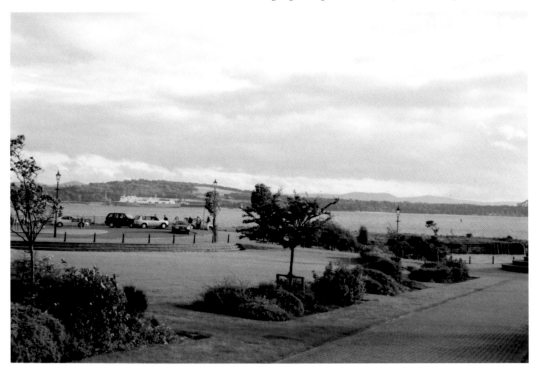

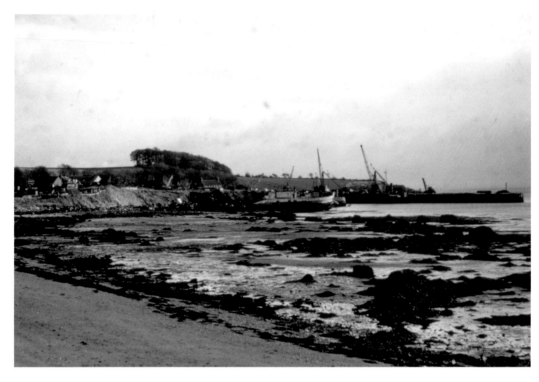

St Davids from the West

When I photographed St Davids from the Inverkeithing path in January 1971, it was a working breaker's yard. Twenty five years later, the new St Davids was just emerging – construction instead of destruction.

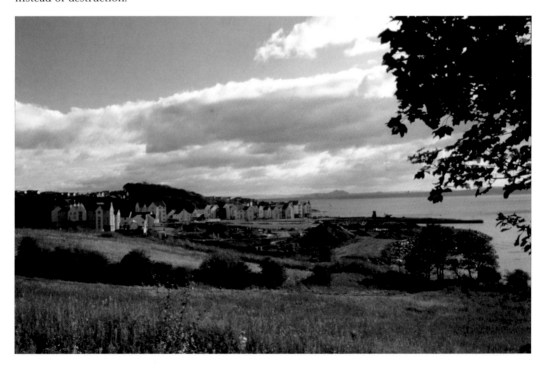

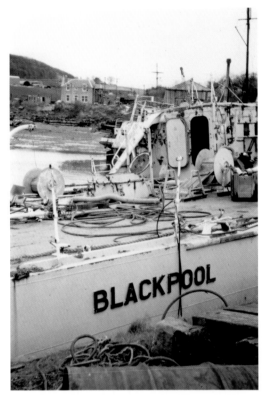

Blackpool No More
The frigate HMS *Blackpool* was one of many vessels that ended their days at St Davids – *Blackpool* coming to the Fife Riviera! The building, top left, at that time was the works' office. In the port's heyday, it was the custom house. The yard was cleared in the 1980s to make way for the new development.

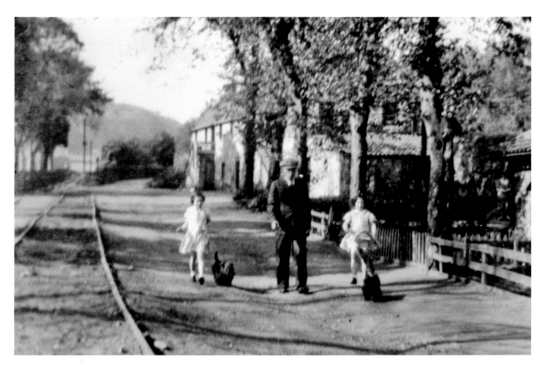

End of the Line

This early 1930s snapshot of a family and their dogs strolling down the Fordell line at old St Davids cannot be replicated. Accordingly, I have selected instead one of the new St Davids from Letham Hill, a view that is only possible after winter winds have stripped the trees bare.

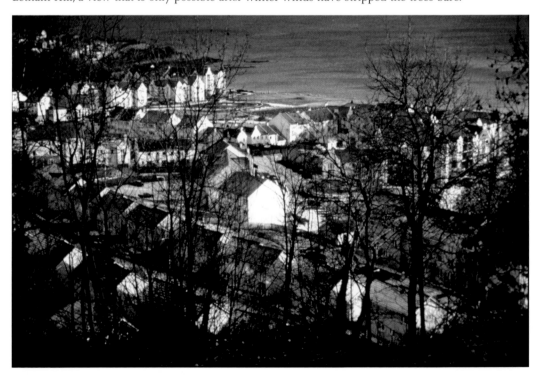

Seafield Farm

New houses stand on what had been fertile farmland. To make way for today's brick and timber dwellings, the stone-built Seafield farmhouse and its old pantile-roofed steading buildings were demolished. The street name, Whites Quay, commemorates the name of the breaker's yard

Letham Farm

Letham Farm, to the north of Seafield, was still a working farm in January 1990 when wheat was being loaded onto a truck. Eight years later it was in the process of demolition. Only the Georgian-style farmhouse and a former farm cottage survive.

The Old St Davids Road

Kathleen Simpson walks along the old St Davids Road in 1993, the only vehicular access to the seaport apart from the railway. Most of the old road has been obliterated, but here, on a short section off the Link Road, the original line of the road can still be discerned.

The Spur Line to Inverkeithing

Here is another old route that has vanished under concrete, namely the railway line that ran from Donibristle Aircraft Repair Yard to Inverkeithing's East Ness pier. Factory buildings now cover its course.

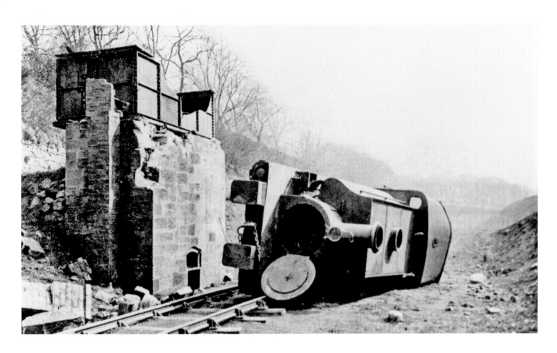

The Fordell Railway

On 13 April 1896 the Fordell Railway's locomotive *Alice* suffered a boiler explosion, the stoker being killed and the driver injured. The locomotive was repaired and continued in service till 1946. At the present time, blasts of a different kind can be heard on the northern section of the former railway line, where opencast operations are being carried out.

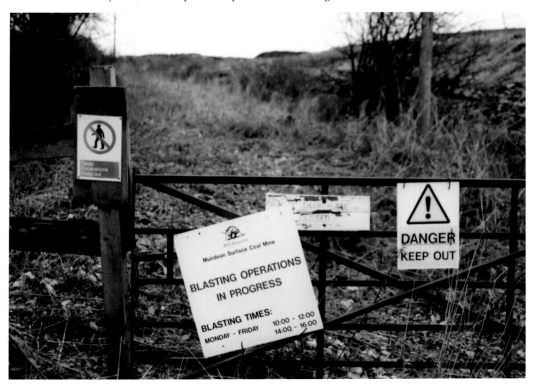

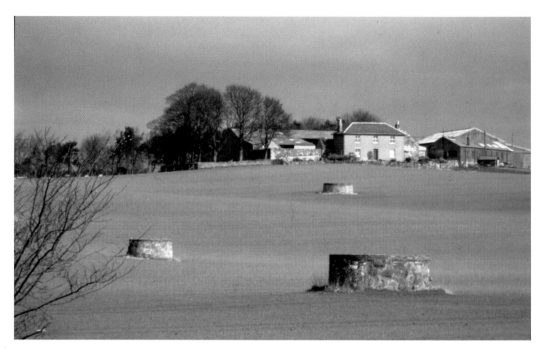

The Price of Coal

The Fordell pits were drained by a day level, an underground channel whose route can be traced by air shafts which protruded from the fields, as snapped here south of Broomieside Farm. As a result of open cast mining, the by-then empty farm and steading were, in March 2010, left precariously perched on the edge of an enormous pit.

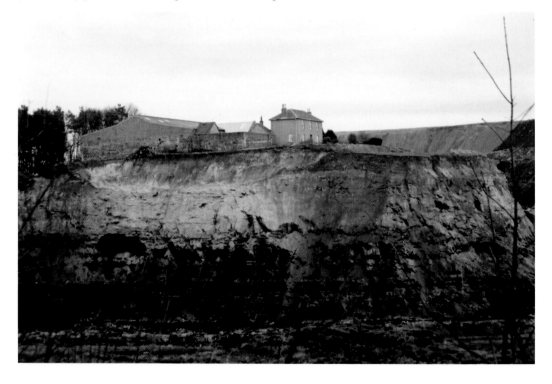

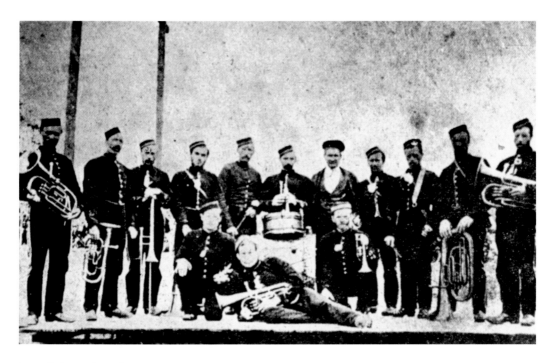

Leisure Pursuits

Of the old mining rows, nothing remains. Other photographs are scanty, but this Victorian-era one of the brass band is one of the few that survive. The Fordell Band played at local events, including the Aberdour Regatta. When drouthy after work, the bandsmen and other colliers headed for one of the buildings that do survive – the Coaledge Tavern, as seen here in 2002 with host Alec Smith behind the bar.

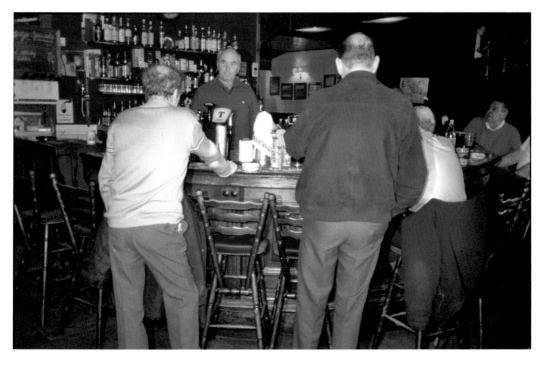

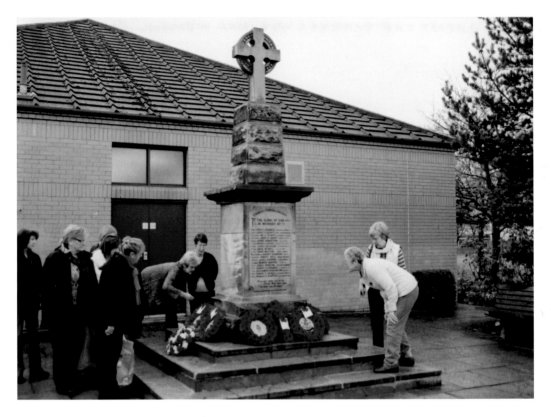

Armistice Day 2009

The last image is of the Dalgety Parish War Memorial. On 11 November 2009, Armistice Day, I was there to record the scene and just before 11 a.m. I was surprised to see the kirk hall door opening and the members of the Ladies' Tap Dancing Club emerging to pay their respects. A fitting conclusion!

Acknowledgements

The great majority of the 'old' photographs and all the 'new' are from my own archive. Nevertheless, I am grateful to Alan Brotchie, George Hastie, Lennox Milne, George Robertson, Dorothy Syme and John Taylor for the use of photographs. Over the years I have received information and assistance from many people, and to them I give thanks. A special mention should be made to Anne Paterson and Fraser Simpson for technical assistance and other support.